002787

ND
553
.M7
N4
1969

New York. Museum of
Modern Art

Claude Monet

Claude Monet Seasons and Moments

by William C. Seitz

The Museum of Modern Art, New York

in collaboration with the Los Angeles County Museum

Reprint Edition, 1969

Published for The Museum of Modern Art by Arno Press

EXHIBITION DATES:

The Museum of Modern Art, New York: March 9-May 15, 1960

Los Angeles County Museum: June 14-August 7, 1960

Published by The Museum of Modern Art, 11 West 53 Street, New York, March 1960

All Rights Reserved

Library of Congress Catalogue Card Number: 60-9682

Designed by Charles Oscar

Reprint Edition, 1969 Arno Press
Library of Congress Catalog Card No. 72-86446

ACKNOWLEDGMENTS

On behalf of the Trustees of the Museum of Modern Art and the Los Angeles County Museum I wish to thank all of those who have given assistance in the preparation of this exhibition.

In large part, my study of Monet has been made possible through the support of Princeton University and the United States Government under the Fulbright Act, for which aid I am deeply grateful. Daniel Wildenstein's catalogue of Monet's *oeuvre*, still in preparation, was the primary source used in locating little-known works. Without it, and Mr. Wildenstein's assistance, the exhibition would have been impossible in its present form. I was permitted to use the Impressionist archive and the photograph files of the Durand-Ruel Gallery in Paris with complete freedom, and also the important material compiled by the Department of Documentation of the Louvre. For aid in arranging loans from France I wish to thank Philippe Erlanger of the Association Française d'Action Artistique; Edmond Sidet, Directeur des Musées de France; Edouard Morot-Sir, Cultural Counselor and Representative in the United States of French Universities; Pierre-Louis Duchartre, Inspecteur Principal des Musées de France; Charles Durand-Ruel. Miss Darthea Speyer, Exhibits Officer, United States Information Service, Paris, was especially helpful in implementing these loans.

For assistance in securing loans I am grateful to Louis Goldenberg, Philippe Huisman, E. J. Rousuck, and John Callais of Wildenstein and Company; Helmut Ripperger of M. Knoedler and Company; F. K. Lloyd of Marlborough Fine Art, Limited; David Carritt, Alexandre Rosenberg, William N. Eisendrath, Jr., Perry T. Rathbone, Haavard Rostrup, Theodore Rousseau, S. Lane Faison, Jr., Ljubisa Jeremic, and John Rewald. Sam Salz gave his help not only in this regard, but also by encouragement and expert council. M. and Mme Michel Monet contributed firsthand knowledge of Monet, as did Jean-Pierre Hoschedé, Mme Germaine Salerou, Mme Ernest Rouart, and André Barbier. Jean Gimpel authorized quotation from unpublished interviews with Monet recorded in his father's journal. Valuable assistance was given by Peter Selz and Ilse Falk, who read the manuscript, and by Irma Seitz, whose aid I have learned to count on. The experienced cooperation of Alicia Legg was essential at every phase of planning, preparation, and installation. The handsome color photographs of Monet's water garden included in the exhibition are the work of Alexander Liberman. For special assistance I am also grateful to Mr. and Mrs. Josef Rosensaft; Mr. and Mrs. Joseph Slifka; The New Gallery, Inc.; Wildenstein and Company; J. H. Whittemore Company.

Finally and especially, I wish to express my sincere appreciation to the museums, collectors, and dealers who graciously lent paintings to the exhibition.

WILLIAM C. SEITZ
Director of the Exhibition

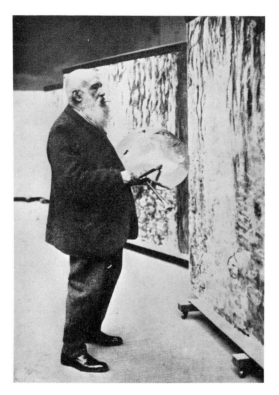

Monet in his studio. (Photo Viollet, c. 1922)

Sometimes, during my melancholy walks, I gaze on this light that inundates the earth, that quivers on the water, that plays on clothing, and I grow faint to realize how much genius is needed to master so many difficulties, how limited is the power of man's mind to put all these things together in his brain. Then I feel that poetry is there Sometimes I catch a glimpse of what must be expressed.

Twenty times I have begun again in order to approach the delicacy, the charm of the light that plays everywhere. How fresh it is! It is soft, faded, rose-tinted. The objects are drowned. There are nothing but tones everywhere. The sea was superb; the sky was soft, velvety. It then changed to yellow; it became warm; then the setting sun gave beautiful violet nuances to everything; the earth, the breakwaters also took on this hue.

Nature is so beautiful, so splendid; it is always in this that my secret torment lies when misery releases its grip a bit. It is a great blessing for us to see, to admire unceasingly, all these splendors of sky and earth, if it were only to admire them; but do not continually mix it with the torment of reproducing them

Eugène Boudin.
Extracts from his notebooks, c. 1854–1859[1]

4

Over a period of almost seventy years—from the fifties, the decade marked by Courbet's realism, to those of cubism, abstract art, and surrealism – Claude Monet produced a virtually unbroken succession of paintings. Including those destroyed or lost, the total could exceed three thousand. Of this number the vast majority are landscapes, seascapes, or riverscapes. Any selection from the lifework of a prolific artist tends to be arbitrary, but in the case of a productivity so unendingly varied as that of Monet it must border on randomness. If it were necessary, at this late date, to argue his greatness, quality might have been the sole consideration; some one hundred canvases cannot begin to typify an unparalleled diversity spread through thirty times that number. Yet it is just this characteristic that should first be understood if one is to know Monet: *the diversity of his landscape paintings derives directly from that of nature, to which, without need for metaphysical justification, he was entirely devoted.*

Before his eighteenth year, the seeds of this dedication were planted in Monet by his first master, Eugène Boudin. Monet's "entire future," Marthe de Fels writes,[2] can be found in Boudin's early notebooks. It was at that time, before 1860, that Boudin was sketching his impressions of clouds, beaches, and sea (marked with the date, time, and wind-direction) in pastel. Baudelaire, as sensitive to sea and sky as he was to currents of culture, pointed out both the poetry and meteorological accuracy of these sketches in his essay on the Salon of 1859.

Admirable artist though he was, Boudin recognized the fugitive magnificence of the world as a challenge too vast for his abilities and energies; but Monet (though his moods of black despair arose from an identical frustration) possessed the ability and the strength, physical and moral, to accomplish what his master could not. Even as a child he was rugged, self-assured, and impatient with theory divorced from practice. At school he drew caricatures of his tutors, or fled their "prison" for the sights, sounds, smells, and movements of the seashore between Le Havre and Sainte-Adresse.[3] An overbearing and swaggering boy, he dismissed Boudin's landscapes with aversion; yet, once induced to accompany him on a sketching trip, young Claude-Oscar experienced what can only be described as an enlightenment: "Suddenly a veil was torn away. I had understood – I had realized what painting could be."[4]

If technical skill, rather than predisposition and the events of life, determined the direction of an artist's work, Monet might have become a great portrait and figure painter. No more forthright domestic scene was ever painted than the magnificent *Luncheon* in Frankfurt (1868). If it had been

completed, the famous *Déjeuner sur l'Herbe*, painted over two years before when Monet was twenty-five, might have been as influential as the masterpiece by Manet from which its title was borrowed. The rejection of the Louvre's *Women in the Garden* by the Salon of 1867 may have been a deciding factor in Monet's life: it blocked his youthful ambition to succeed publicly as the first outdoor painter of full-scale figure groups. He also painted fine still-life compositions, but except for flowers, which he adored, such work was an exercise, or a way to pass bad weather. The uniqueness of his genius unfolds most fully in his landscapes.

It should be recognized at the outset, however, that the cycles painted, each from a single motif, at different seasons of the year or moments of the day – and they were the outcome of Monet's naturalism – remain the most controversial of his works, and that the taste of the years 1930-1950 much preferred the better-known style of the seventies, often regarded as the only "true" impressionism. To cite but two random examples of the fluctuating estimate of their importance over the past seventy years, the Haystack series, hailed as a revelation of "the poetry of the universe" when it was exhibited in 1891,[5] was commonly regarded as an unfortunate venture by the 1940s; the series representing the façade of Rouen Cathedral, described in 1895 as "a thunderous revelation of what the modern spirit can do when allied with ancient art"[6] appeared to a world-famous critic in 1949 as a "disastrous" choice of subject matter because "grey Gothic façades do not sparkle. In an attempt to make them vehicles of light Monet painted them now pink, now mauve,

now orange; and it is evident that even he . . . did not really believe that cathedrals looked like melting ice-creams."[7]

To certain observers, therefore, the present selection of landscapes – especially those after 1880, the beginning of Monet's alleged decline – may appear bizarre; yet even they must agree that works of art do not cease to change once they are signed and dated, that each generation discovers its own values, and that standards of artistic worth have never remained static.

Monet's unstable critical fortune, from his gradual acceptance during the eighties to his fame in the nineties, his rejection in the wake of cubism, and the recent rediscovery of his water landscapes by artists, critics, dealers, collectors, and museums calls attention, moreover, to the very real differences that separate various phases of his development. Even the most cursory survey – from the great *Seine at Bougival*, let us say, to the engulfing jungle of the last versions of the Japanese Footbridge series (page 48) painted just before his cataract operation in 1923 – reveals a diversity arising from the artist's psyche as well as from nature and vision. Neither his choices of subject nor his modes of seeing, composing, and executing were accidental, nor were they dictated by a systematic theory. Monet's changes were the result of interrelated factors, and consideration of them suggests a fascinating and complicated investigation that would chart their month-by-month permutations. Yet, beneath the eddies in the flow of his art always lay an unswerving determination to paint truthfully the world in which he lived.

In 1883 Jules Laforgue, with Monet and

Pissarro in mind, wrote that the "impressionist eye" was the "most advanced eye in human evolution."[8] It would be false to approach the landscape of Monet without this visual emphasis. Joachim Gasquet quotes Cézanne as stating that Monet was "the most prodigious eye since there have been painters"; as predicting his entry into the Louvre; as elevating him above Constable and Turner.[9]

For the historical role of pushing naturalism to its bursting point Monet's background, physique, and personality (at least as it developed through feats of inner adjustment) were ideally fitted. He loved solitude and disliked city life. "I assure you that I don't envy your being in Paris," he wrote to the painter Bazille from Fécamp in 1868. "Frankly, I believe that one can't do anything in such surroundings. Don't you think that directly in nature and alone one does better?"[10] Physically, he was vigorous enough to withstand the rigors of a life that bore as much resemblance to that of a hunter or fisherman as it did to that of a studio painter. He could appear before his motif at dawn and paint all day in the hot sun, in wind or snow, or even in the rain. At the age of fifty-five he worked outdoors in a Norse winter, and also on the frozen Seine near Giverny, warming his hands on a hot water bottle when they became too stiff to hold the brush. Like his friends Zola and Clemenceau he was skeptical, distrustful of intellectual or religious dogma, but had tremendous respect for sense data as the basis for truth. Toward the authority of the Renaissance tradition—quite differently from Manet, Degas, or even Courbet—he showed a radical disrespect that kept academic solu-

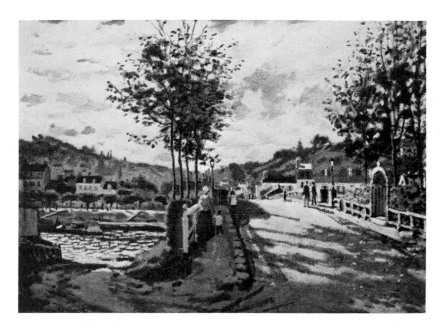

The Seine at Bougival. (1869). Oil, 25 × 36". The Currier Gallery of Art, Manchester, New Hampshire

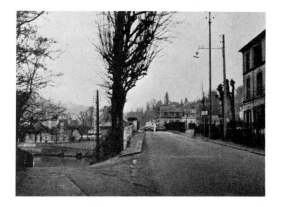

View across the bridge toward Bougival. (Photograph, 1958)

7

tions and clichés from inhibiting his sensibility.

Regarded in the light of the landscape of van Gogh, Soutine, or the German expressionists, one marvels at Monet's ability to preserve the purity of his impressions from emotional deformation. It is revealing to consider his scenes of the Seine against the background of the harrowing events in his life from 1868, the year of the first riverscapes, to the death of Camille in 1879. Until the melancholy series of the river in flood which began that same year hardly a trace of dread, of sadness, of "pathetic fallacy" can be detected. The moods of these lyrical canvases derive solely, it would seem, from the softness, fragrance, and luminosity of the French countryside and the Seine.

Essential to Monet's impressionism, also, was his ability to preserve appearances from adulteration by the conceptualized visualization of practical life. It is in this context that we must understand his stated desire to see the world through the eyes of a man born blind who had suddenly gained his sight: as a pattern of nameless color patches.[11] Aldous Huxley, in recounting his experiences under the influence of the ego-reducing drug mescalin, calls attention to just this quality of perception. Viewing a group of ordinary objects, he was astounded by the beauty of a pattern of sun and shadow. "For what seemed an immensely long time I gazed without knowing, even without wishing to know, what it was that confronted me. At any other time I would have seen a chair barred with alternate light and shade. Today *the percept had swallowed up the concept* [italics not in the original]. I was so completely absorbed in looking, so thunderstruck by what I actually saw, that I could not be aware of anything else. Garden furniture, laths, sunlight, shadow—these were no more than names and notions, mere verbalizations, for utilitarian or scientific purposes, after the event."[12]

Monet's immersion in perceptual reality unified the dualism typical of so many classical, romantic, and expressionistic landscape painters. However a new kind of anguish, like that of Boudin, resulted from the very totality of his involvement—from his drive to capture the full range of natural effects, however impalpable or transitory. "I am in a black mood and profoundly disgusted with painting," Monet wrote to his friend Gustave Geffroy in 1890. "It is a continual torture! . . . It is enough to drive one raving mad, to try to render the weather, the atmosphere, the ambiance."[13] The passage of time became a maddening challenge; inclement weather, if it prevented outdoor work, led to deep discouragement.

Thus Monet's emotional life did become enmeshed with his subjects, but in an empathetic rather than a projective way. "I have been here almost two months," he wrote to Berthe Morisot in 1886 from the island of Belle-Ile-en-Mer, "a terrible, sinister country, but very beautiful, which attracted me from the first moment; . . . the ocean is so beautiful I have begun a quantity of studies and the further I proceed the more astonished I become: but such terrible weather. I work in the rain and wind."[14] He also wrote to Durand-Ruel, telling of his difficulty in rendering "that somber and terrible aspect."[15]

It is as if, within Monet's psyche, there were a scale analogous to that of the weather,

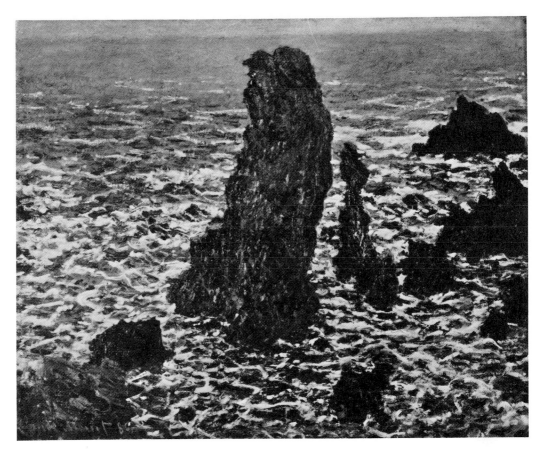

Rocks at Belle-Île (The Needles of Port Coton). 1886. Oil, 24 × 29″. Collection Mr. and Mrs. Erik Meyer, Copenhagen

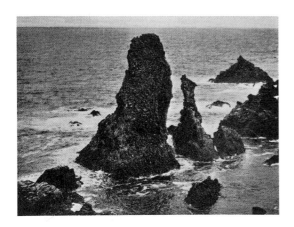

The Needles of Port Coton, Belle-Île.
(Photograph, 1957)

grading from chromatic luminosity, vibrant with light and joy, through an infinite range of tinted and toned grays implying as many median emotional nuances, and finally down to blackness; nullity; immobility; non-being. Monet was afraid of the dark, which he associated with death. In 1879, immediately after the death of his first wife, Camille, he painted her motionless face, appalled by the habitual reflexes that compelled him automatically to dissociate the fluctuation of colored light over her skin from the cold flesh on which it fell.

To eyes accustomed to the mahogany browns of the Barbizon school landscapes, or even the silvery tones of Corot, the brighter colors and accentuated brushstroke of Monet's pictures of the 1870s were brutally harsh, and they seemed utterly false to appearances. To modern taste, however, which discerns a reference to nature even in the most abstract painting, certain works of Monet seem to narrow, and sometimes almost to close, the gap between nature and art. Almost never are the objects he represents shifted, as in most post-impressionist landscapes, from the relative positions which they would have occupied on a photographer's ground glass. And despite all adjustments of rhythm, color, and contour, the impact of an original impression is always retained. Avoiding dry, detailed empiricism by strong brushwork, Monet came closer to perceptual reality than has anyone else.

Still and motion photography in color have shown us, however, that the world has a million modes of appearance, not one; and that a neutral stone façade can appear mauve, green, blue, or indeed any other color tone, depending on the light and atmos-phere. Monet despised the unrelieved local colors, enameled surfaces, static bulks, and hard edges of academic painting. Reacting against them, and naturally drawn toward the world's shifting panorama, he beheld an animated and multi-hued curtain of interacting color patches, opaque or transparent, dull or brilliant, textured or smooth, sharply edged or merging. As his early landscapes show, he was a consummate master, like Corot, of closely related color tones; and though his modes of visualization and representation were to change many times, it is the perception of the world as color and pattern that underlies them.

THE SERIES

The "series" method of representing nature originated in an attention to more and more specific phenomena of weather, and is inseparable from Monet's choice of subjects, visualization, and style. Boudin had already discovered that "everything that is painted directly and on the spot always has a force, a power, a vivacity of touch that cannot be recreated in the studio,"[16] and had also recognized that the suffusion of a single quality of light over a scene results in a new kind of compositional unity. In 1864 and 1865 Johan Jongkind, master of both Monet and Boudin, painted several views of Notre Dame Cathedral and the Seine from the same position but under different lighting conditions, though according to his practice only preparatory sketches in watercolor were painted on the spot. A year or two later Monet finished—in all probability outdoors—two studies of an identical view

of the road from the now-famous Ferme Saint-Siméon to Honfleur, one with the trees in full leafage and the other with the countryside completely covered with snow.[17] Here are the starting points of a development that combined a constantly narrowing temporal focus, an increasing probity (and consciousness) of vision, an attendant increase of psychosomatic tension, and a continuous improvisation of new formal equivalents for visual phenomena.

Although they make up a related group, the masterful early studies Monet painted on the pebble beach at Sainte-Adresse do not constitute a "series" – i. e., a sequential cycle of light, weather, or season – for they share a common silvery sun-and-cloud tonality. Pictures like these demonstrate, nevertheless (as did the outdoor sketches of Constable fifty years before), how intimate contact with the elements enforces live brushwork. Movement – sweeping in the sky, chopped and sparkling on the distant water, crashing and boiling as the surf breaks on the shore, or captured in a silhouetted sail – is the theme; under the pressure of time and the situation hand and brush make a running translation into pigment. As in the works of Boudin and Jongkind, open sky occupies a large portion of the picture surface, and the interpretation of space is traditional in that the horizontal planes of the sea and beach, and the ceiling of clouds, recede strongly toward the horizon. This is also true in the three well-known urban pictures painted from the Louvre. However, in the finest of these, the *Quai du Louvre*, Monet's later concern for two-dimensional pattern is already evident. Accentuated brushwork translates the play of light on leafage or

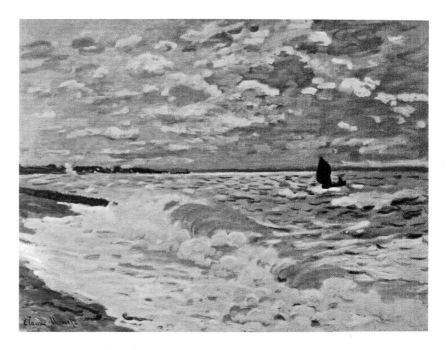

View of Le Havre from Sainte-Adresse. (1868). Oil, 23$^1/_2$ × 31$^1/_2$". Carnegie Institute, Pittsburgh

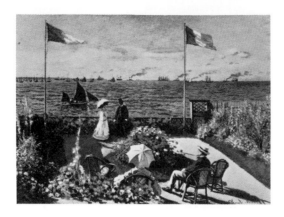

The Terrace at the Seaside, Sainte-Adresse. (1866). Oil, 38 × 51″. Collection The Reverend Theodore Pitcairn, Bryn Athyn, Pennsylvania

water, and the movement of horses, figures, and carriages.

During these years Monet was also making other discoveries. In *The Terrace at the Seaside, Sainte-Adresse*, which shows his father gazing seaward, flower beds are interpreted as a rhythmic staccato of warm and cool spots; at Honfleur, in the winter, he observed the wide chromatic range, from warm lights to bright cerulean shadows, of snow subjects; on the Seine, along with the quick movements of vacationers and the parade of small boats, he explored the water surface as well. "When landscape is mirrored in water," wrote D. S. MacColl (a now all-but-forgotten commentator on impressionism) in 1902, "the forms of trees, buildings, and other objects are not only simplified and broadened, but inverted and distorted, for in any troubling of the surface by ripple or wave the water is broken up into a series of mirrors tilted at different angles and with various degrees of convexity and concavity.

Into the shivering fragments of these, elongated, shortened, and twisted images of objects on the bank are worked kaleidoscopically bits of sky and cloud, and this undulating hash of half-coherent forms which we can gaze at almost as abstract colour and tone gives the nearest [approach] to the dream of an art that should be a play of colour only. Something of this state of mind Monet applied to his seeing of unreflected objects, treating trees, for example, by loose groups [of] touches that indicate roughly the place of reflected and transmitted lights and shadows . . ."[18] It is impossible to overestimate the importance of water, in its fusion with reflection, light, and movement, for Monet's art. Through its mediating image the material world is both abstracted and animated. Within a realistic framework brush and pigment are freed to seek their own path toward an independent beauty, and the painter is given an object lesson in the transformation of nature into art.

But before 1870, and even in the bold beach studies at Trouville, Monet's work does not reveal the concern for the palpability of atmosphere that gains such importance after 1886. He must have been familiar with the fogs that so often blanket coastal Normandy, but until his wartime visit to England the air that fills his picture-space is usually crystal clear. In London he and Pissarro saw the Thames River with its luminescent fogs, and at the museums the sunsets, moonlights, storms, and dissolutions of Turner. "At one time I admired Turner greatly," Monet said in 1918; "today I like him much less . . ."[19] There is reason to believe, also, that he may have seen one or two of the misty and patternized Nocturnes of

Whistler. But whatever the reasons or influences, it can be said that his London studies show a new interest in atmosphere.

Monet was of course not the first French artist to represent fleeting effects: a critic of the Salon of 1859 accused the painter Ziem of imitating "the bad period of the Englishman Turner";[20] Daubigny showed a *Sunset* and a *Moonrise*;[21] the Salon of 1864 included a work of Chintreuil entitled *Sun Dispelling Mist*;[22] that of 1865, his *Evening Vapors*, and Jongkind's *Moonlight Effect*.[23] Such subjects, it is apparent, were common long before Monet attempted them, and go back to Claude Lorrain and even earlier masters; but the very belatedness of Monet's interest in them indicates its authenticity. It was not imaginative, hypothetical, or drawn from tradition, but the result of direct perception. Except for the isolated studies of Leicester Square (1899–1904), night scenes, a stock-in-trade of Jongkind, Cazin, and others, are not found in Monet's art, for, by necessity, his day began with sunrise and ended by dark. One work can serve to mark the new concern for atmosphere: the celebrated *Impression* of 1872 (page 54) that, hung in the first impressionist exhibition two years later, christened the new movement. Not boats and harbor installations, but the red sun and its light path swathed in blue mist and darkness, is its subject. Almost thirty years later on the balcony of London's Savoy Hotel, hypnotized by the mystery of the fogbound Thames, Monet was to represent such effects in canvas after canvas.

The landscapes Monet painted at Argenteuil between 1872 and 1877 are his best-known, most popular works, and it was during these years that impressionism most closely approached a group style. Here, often working beside Renoir, Sisley, Caillebotte, or Manet, he painted the sparkling impressions of French river life that so delight us today. Following the example of Daubigny, he outfitted a *bateau atelier*, in which he was portrayed by Manet while painting (page 54).

Whether in scenes of the smiling Seine, fields of wildflowers, or village streets piled high with snow, the Argenteuil landscapes are human in scale and reference. Where a passage of grass, foliage, or water demands it, the color is vibratory and broken; but almost as often it is applied in virtually flat areas. And the brush and color treatments are never schematic; they adapt themselves to the surfaces, movements, and effects of the river, town, and countryside with an entirely relaxed mastery. Natural textures are interpreted by calligraphic analogy. Only a few river views, painted in 1875 or later, anticipate the oscillating technique that (as in the later series works) seems to raise the pigment touches from the objects they depict and circulate them freely in the air.

During 1876, 1877, and 1878 Monet's life was upset by the hostile reception then accorded all impressionist painting, dire financial distress, the birth of his son Michel, several domestic relocations, and Camille's increasing illness. These were nevertheless years richly productive of both figure and landscape painting – at Argenteuil and Montgeron (the estate of M. Hoschedé, the department store executive and patron of the arts, whose family was subsequently to join that of Monet) and, for the last time, in Paris. These cityscapes are as important in Monet's stylistic growth as they are beauti-

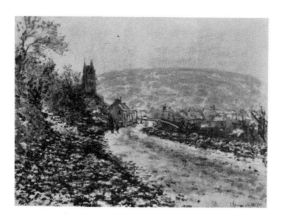

Entrance to the Village of Vétheuil: Snow. (c. 1878). Oil, $23^3/_4 \times 31^7/_8$". Museum of Fine Arts, Boston

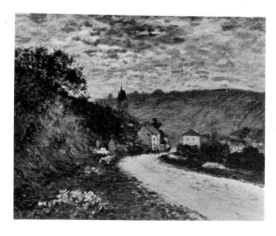

Entrance to the Village of Vétheuil. (c. 1878). Oil, $19^1/_2 \times 24$". Collection Mrs. N. B. Spingold, New York

ful. The third impressionist exhibition, of 1877, included at least seven revolutionary studies of the yards and skylighted train shed of the Saint-Lazare Station seen against an iridescent backdrop of sky, buildings, and the elevated thoroughfare, the Pont de l'Europe. Scrutinizing this totally urban and mechanical motif, with its drama of arrivals and departures taking place amid a spectacle of sun, smoke, and steam, Monet may well have been seized, as Georges Rivière was at the time, by "the same emotion as before nature."[24] In the puffing, blowing, merging, and dissipating vapors that intercepted and suspended light and shadow Monet found a new subject and treatment of space. Physical objects have lost bulk through flat pattern, color, and summary handling while air has become visible and almost sculptural.

The first canvases that Monet undertook after he, his wife Camille, and their two sons arrived at Vétheuil in 1878 represent the entrance to the village with their new home – one unit of a tripartite row house that is still intact – on the left side of the road. Alice Hoschedé and her six children joined them later; her daughter Germaine has recalled the delicate figure of Camille relaxing on a divan before the door when the weather was fine. By comparison with the Saint-Lazare Stations – a related group – these winter landscapes are a real cycle of season and weather. Bold and dextrous in their brushwork, but marvelously soft and delicate, they contain no spectral color, but take their key from the sad tones of dead foliage, grass, and leaves, and from the strange brown-violets of soiled snow and mud. The sky is murky or heavy with clouds. Earlier, in Argenteuil, Monet had painted a variety

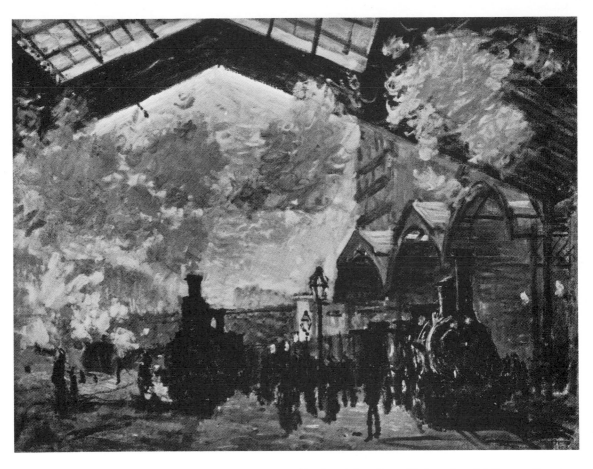

Saint-Lazare Station. (1876–77). Oil, $21 \times 28^1/_2$″. Collection The Hon. Christopher McLaren, London

of snow effects, in sunny or overcast weather. By individual touches of the brush, he even represented the flakes of falling snow that filled the air.

Across the road from the house was a terrace from which a stairway once led downward to a garden and the river bank. Here Monet moored his studio boat. From it, between 1878 and 1881, he painted the Seine, the two-mile island of Saint-Martin, and both shores, at every hour of the day and season of the year. It was at this time, in all probability, that he began to utilize a slotted box containing several canvases of a given size from which, on returning to his motif from day to day, he could choose the one that best conformed to the light of the moment, continue working until the light changed (seldom more than half an hour), and replace it with another. In conversations during the nineties Monet explained the reasons for this method. He believed that the first look at the motif was likely to be the truest and most unprejudiced one, and that as much of the canvas as possible should be covered at the first session, no matter how roughly, "so as to determine at the outset the tonality of the whole."[25] He often began with wide, separated strokes, as in *The Harbor at Dieppe*, afterward filling the spaces between them with others as the subject began to emerge more clearly. He felt that it was essential to cease work the instant an effect changed in order "to get a true impression of a certain aspect of nature and not a composite picture."[26]

In this new environment, farther from Paris than Argenteuil, with the picturesque villages of Vétheuil and Lavacourt facing each other from opposite banks of the river, Monet found a superb, but less suburban, motif. A large exhibition could be assembled solely from canvases of this period and locality. It would show nature in many moods, some as lyrical as those of Argenteuil, but would be dominated by a desolate series known as the Débâcles: the flooded river choked with floating blocks of ice; trees crushed by their weight; small boats inundated and imprisoned; sullen sunsets sinking into an unpopulated wasteland.

1880, the year in which Monet announced his independence of the impressionist group, marks an important change in his style and choice of subjects. During the next, intensely busy decade he worked at Poissy, at Etretat and many other locations along the Norman coast, on the Italian and French Rivieras, in Holland, at Belle-Ile, in the rugged valley of the Creuse river, and of course along the Seine and at Giverny, his home after 1883. It is a spectacularly varied sequence of new sites and brilliant formal innovations; a geographical and stylistic quest that led him to seek more and more dramatic and often brightly colored subjects.

Certain common procedures and solutions underlie the works of this period, though they inhere as much in the motif as in its interpretation. As before, compositions are "discovered" by blocking off a portion of a scene without rearranging its elements, but now it is done with much less regard for the Western landscape tradition. The radical cropping calls to mind Japanese prints, of which Monet became an avid collector. As in *Fisherman's Cottage on the Cliffs at Varengeville* (one of a large group), the surface is often divided into a very few large areas. Horizontal recessions are avoid-

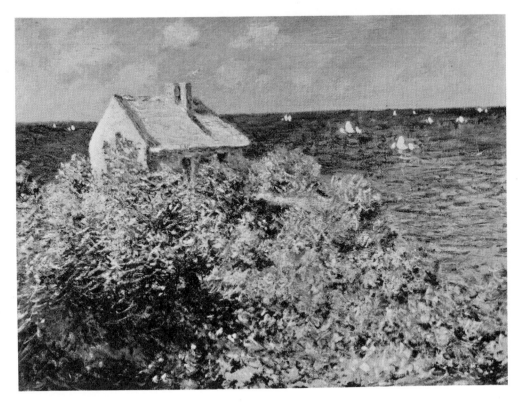

Fisherman's Cottage on the Cliffs at Varengeville. 1882. Oil, 24×34³/₄″. Museum of Fine Arts, Boston

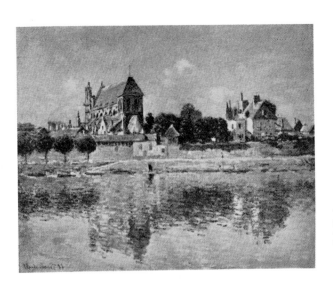

The Church at Vernon. 1883. Oil, 25¹/₂×32″. Collection Mr. and Mrs. John Barry Ryan, New York

17

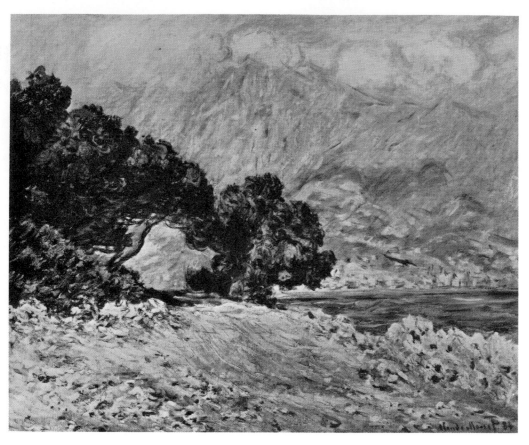

Cap Martin, near Menton. 1884. Oil, 26³/₄×33″. Museum of Fine Arts, Boston

Torrent on the Petite Creuse. 1889. Oil, 25³/₄ ×36¹/₄″. Collection Miss Adelaide Milton de Groot, New York

18

ed or gently coerced toward the vertical. Within the thoughtfully contoured shapes a broad vocabulary of coloristic calligraphy simultaneously translates into pigment both the vibration of light and the rhythms and textures of grasses, earth, clouds, foliage, rock surfaces, and waves. (One suspects that those painters and calligraphers of China who originated the traditional modes must have made similar translations from first-hand perceptions.)

If a sufficient number of works from the eighties could be brought together the degree to which the series method is potential in them would be evident. One could assemble sequences of high and low tide; fair and stormy weather; morning, noon, and sunset; or, as in the various representations of the huge, arched Manneporte at Etretat (pages 20–21), calm and rough sea. The effects of the change from jeweled morning light to the sun-and-shadow patterns of afternoon on the coarse and striated rock face, and from a lapping to a rolling surf are enlarged, clarified, and spread flat before the eyes as if by a magnifying lens.

To see such paintings together would also reveal Monet's increasing tendency to ignore local, theoretically invariable color tones in favor of the induced coloration of the total environment. As a corollary, the individual brushstrokes become smaller by 1888, emphasizing optical mixture more than calligraphic naturalism. At Bordighera and Menton in 1884, though the brushing and brilliant hues predict the manner of van Gogh and the fauves, Monet already saw the need for "a palette of diamonds and precious stones";[27] four years later at Antibes, in one of the first systematically cyclical

Antibes. 1888. Oil, $29^1/_8 \times 36^1/_2$". The Toledo Museum of Art

19

Last year I often followed Claude Monet in his search of impressions. He was no longer a painter, in truth, but a hunter. He proceeded, followed by children who carried his canvases, five or six canvases representing the same subject at different times of day and with different effects.

He took them up and put them aside in turn, following the changes in the sky. And the painter, before his subject, lay in wait for the sun and shadows, capturing in a few brushstrokes the ray that fell or the cloud that passed. . . .

I have seen him thus seize a glittering shower of light on the white cliff and fix it in a flood of yellow tones that, strangely, rendered the surprising and fugitive effect of that unseizable and dazzling brilliance. On another occasion he took a downpour beating on the sea in his hands and dashed it on the canvas - and indeed it was the rain that he had thus painted

Guy de Maupassant. *Etretat, September* 1886[28]

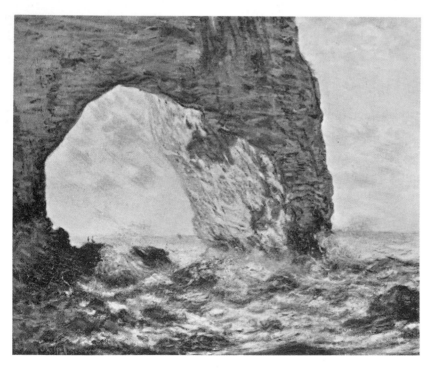

The Cliff at Etretat (La Manneporte). 1883. Oil, 25³/₄×32″. The Metropolitan Museum of Art. Bequest of William Church Osborn

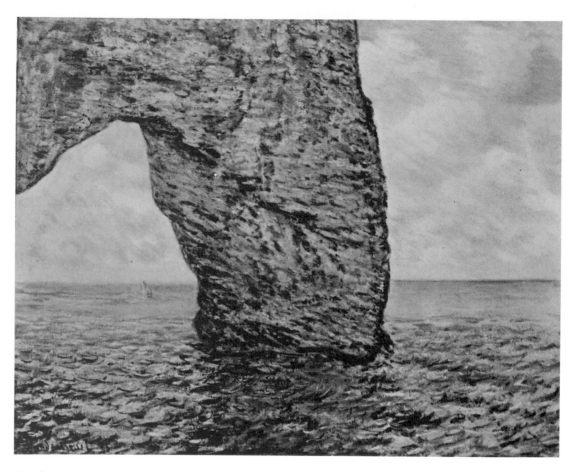

The Manneporte, Etretat. 1885. Oil, 26 × 32¹/₄″. Collection Baron and Baroness
Philippe de Rothschild, Paris

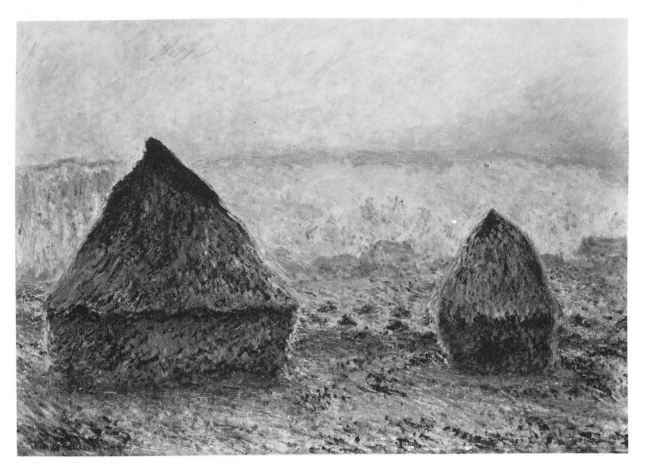

Haystacks at Giverny. 1884. Oil, 25³/₄×36¹/₄". Collection Mr. and Mrs. Josef Rosensaft, New York

When I began I was like the others; I believed that two canvases would suffice, one for gray weather and one for sun! At that time I was painting some haystacks that had excited me and that made a magnificent group, just two steps from here. One day, I saw that my lighting had changed. I said to my stepdaughter: "Go to the house, if you don't mind, and bring me another canvas!" She brought it to me, but a short time afterward it was again different: "Another! Still another!" And I worked on each one only when I had my effect, that's all. It's not very difficult to understand.

Claude Monet, 1920[29]

portrayals of light, his almost pointillist touches have just this effect, and the enduring tones of leaves, branches, and earth are wholly supplanted by the scintillating permeation of a Mediterranean morning, noon, and afternoon. With this group the series method is fully postulated.

It was in 1888, also, that Monet painted at least two studies of trees in a field near Giverny, all but obliterated by fog. The subject brings to mind one of his stories from the first years at Vétheuil. In dire need of money, he offered a view of the village church seen through a mist over the Seine to one of his early patrons, the opera singer Jean-Baptiste Faure. "Keep your canvas my friend," was the response, "I see nothing on it." With characteristic stubbornness, Monet thereafter refused to sell the study. During the war he rejected an offer of 100,000 francs. "For a million I would not want to part with it," he explained later,[30] and the picture is still in the collection of his son Michel.

An eagerness to attempt untried and unpictorial motifs was an important facet of Monet's genius. His many studies of fog and mist are still puzzling to unprepared spectators; but once accustomed to paintings that contain no solid point of reference one can see with what fidelity Monet was able to represent the ravishingly delicate effects of early morning and the enigma of a world hidden behind opalescent mist, eliciting the shadowy presence of things at a distance by accurate color and tone relationships and masterfully worked pigment textures. Compositionally, a similar boldness is evident in *Torrent on the Petite Creuse* (page 18), painted in 1889 at Fresselines: its frame encloses nothing but water rushing by a strip of shore.

THE HAYSTACKS

The majority of Monet's output during the nineties falls into sequential groups, each representing one subject in many versions, as a cycle of light, weather, and sometimes of season. Except for a painting trip to Norway in 1895, where he did the series of Mount Kolsaas, his search for extravagant material was temporarily abandoned in 1890 for a more introverted comtemplation of less spectacular motifs nearer home. Of these the first was the group of haystacks that stood on the slope above Monet's farmhouse in the fall and winter. Although the earliest versions are dated 1884, the year after his arrival at Giverny, when the search for drama was still on the rise, they already evince the exclusiveness of intent typical of those exhibited in 1891. The bucolic theme, moreover, is divested of every shred of the sentiment traditionally associated with it. This anti-picturesque blandness was a necessary prerequisite to Monet's new aims, for brilliant local color and topographical appeal would have deflected or overpowered them. Inert and porous, set in the midst of neutral or snow-covered surroundings, the masses of piled hay are vitalized, and become one with their background, through the momentary permeation of a unifying light. They are the passive modulators of a wholly immaterial life.

Monet has described the goal of the Haystacks (page 26) as "instantaneity." A totally realistic principle, it was at the same time an implicitly abstract mode of pictorial unification. With the physical bulk of objects absorbed by the luminous medium encircling them, the colored particles – at once

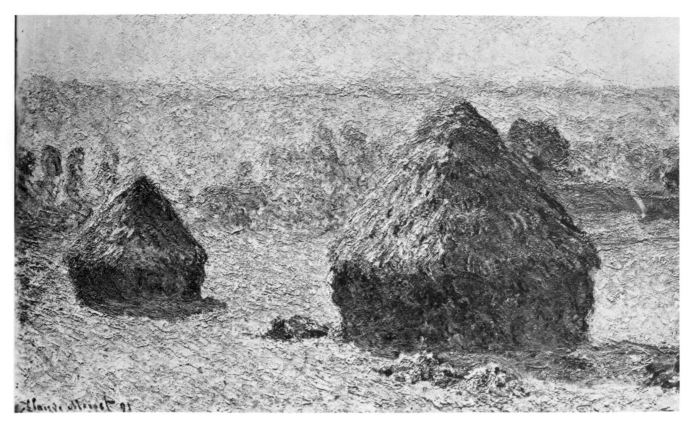

Haystacks, end of summer. 1891. Oil, $23^5/_8 \times 39^3/_8''$. Collection Durand-Ruel, Paris

I am working terribly hard, struggling with a series of different effects (haystacks), but the sun sets so fast that I cannot follow it I am beginning to work so slowly that I am desperate, but the more I continue, the more I see that a great deal of work is necessary in order to succeed in rendering that which I seek: "instantaneity," especially the "enveloppe," the same light spreading everywhere, and more than ever I am dissatisfied with the easy things that come in one stroke.

<div align="right">Claude Monet, October 7, 1890 [31]</div>

Previously [before seeing a Monet Haystack at an exhibition in Moscow in 1895] I knew only realistic art Suddenly, for the first time, I saw a "picture." That it was a haystack, the catalogue informed me. I could not recognize it. This lack of recognition was distressing to me. I also felt that the painter had no right to paint so indistinctly. I had a muffled sense that the object was lacking in this picture, and was overcome with astonishment and perplexity that it not only seized, but engraved itself indelibly on the memory and, quite unexpectedly, again and again, hovered before the eyes down to the smallest detail. All of this was unclear to me, and I could not draw the simple consequences from this experience. But what was absolutely clear to me was the unsuspected power, previously hidden from me, of the palette, which surpassed all my dreams. Painting took on a fabulous strength and splendor. And at the same time, unconsciously, the object was discredited as an indispensable element of the picture

<div align="right">Wassily Kandinsky, 1913 [32]</div>

dancing points of light and touches of pigment – seem to adhere, like ice on a window pane, to the actual canvas surface. They gather in a translucent but tactile crust with a beauty independent of subject matter.

On a path parallel to that which connects Cézanne with cubism, but distinct from it, the Haystack series stands at a crucial point: it marks an outpost of realism, specific in both time and place, and simultaneously foreshadows the autonomy of pure painting. Wassily Kandinsky's account of his confused enlightenment before a *Haystack* that he saw in Moscow in 1895 like Monet's account of his own experience while watching Boudin paint out-of-doors sometime before 1858, evidences a significant revision of philosophical outlook.

POPLARS ON THE EPTE

The concurrent existence of two stylistic poles, the one rectilinear and the other curvilinear and free, is a historic characteristic of French painting. After 1850 realism dissolved this dualism, but in the post-impressionist period the two modes re-emerged. Monet's geometric predisposition is apparent as early as 1871, and later in the horizontals of shore lines, the rectangles of bridges and buildings, and the masts and rigging of sailboats. In the eighties the scenes of Bordighera and Menton move toward the opposite extreme, and the Belle-Ile seascapes oppose seething seas and tortuous rock contours to starkly ruled horizons.

Though neither manner is approached in the Haystacks, their primitive architectural form has an interesting connection with the groups to follow. Monet was stimulated to paint the series Poplars along the Epte by the stately procession of their tall trunks. Some versions – especially the sketch in the Tate Gallery, which Monet valued highly – are direct and spontaneous; *Poplars, wind effect*, despite its freedom of brush, is geometric; in others, verticals and binding diagonals become predominant. Finally, the almost square format of the close-up *The Four Poplars* (page 29) isolates the lower sections of the trunks, the horizontal bank, and the reflected image in a two-dimensional geometric design spaced with obsessive care and parallel to the canvas surface. As in the later art-nouveau landscapes of Gustav Klimt, however, the verticals waver between the swaying lines of growth and geometry, as if Monet sensed a fusion of the two poles in nature.

Considered as a cycle of light, this series exhibits more clearly than ever Monet's substitution of atmospheric color for the material pigmentation of objects. Certain of the effects he sought lasted, it is reported, only seven minutes, or "until the sunlight left a certain leaf." Painted (according to a neighbor of Monet) "from a broad-bottomed boat fitted up with grooves to hold a number of canvases,"[33] the Poplars unfold a fragile poetry of summer in France through unnameable gradations, modulations, and juxtapositions composed of such hues and tints as cobalt, robin's-egg, jonquil, gold, chartreuse, and lilac. As unseizable by the mind as they are penetrating to the senses, their optical mixture cannot be stilled into static color tone. The partial fusion dances with the energy of both atmosphere and

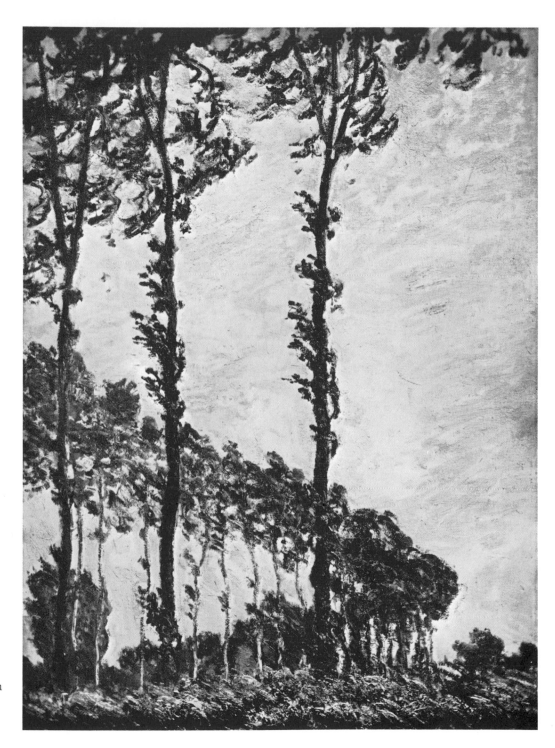

Poplars, wind effect. 1891.
Oil, $39^3/_8 \times 28^3/_4''$. Collection
Durand-Ruel, Paris

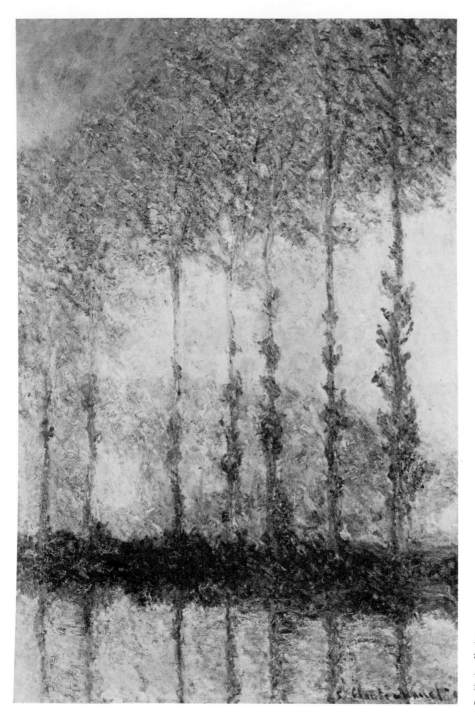

Poplars. 1891. Oil, $39^1/_2 \times 25^3/_4''$. Philadelphia Museum of Art. Bequest of Anne Thomson as a memorial to her father Frank Thomson, and her mother Mary Elizabeth Clarke Thomson

I had to buy the poplars in order to finish painting them. . . . The township of Limetz had put them up for auction. I went to see the mayor. He understood my reasons, but could not postpone the sale. I had no other expedient but to appear at the auction; not a pleasant prospect, because I said to myself: "They'll make you pay dearly for your whim, 'mon bonhomme'!" Then I had the idea of appealing to a lumber dealer who wanted the wood. I asked him how high he intended to bid, and agreed to provide the surplus if the bidding went above his figure on the condition that he buy in my place and leave the trees standing for a few more months. It was done that way, but not without damage to my purse.

Claude Monet [34]

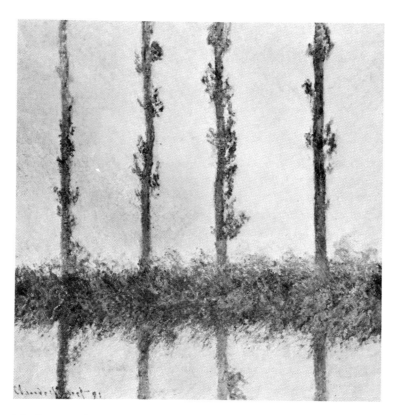

The Four Poplars. 1891. Oil, $32^1/_4 \times 32^1/_8$". The Metropolitan Museum of Art. Bequest of Mrs. H. O. Havemeyer. The H. O. Havemeyer Collection

subjective visual sensation. To critics who discussed the exhibition in 1892 this series, like the Haystacks and the Cathedrals, expressed a cosmic pantheism. Monet's power was seen to lie in his ability to make a "purely transient phenomenon" represent "the sensation of duration, and even of eternity."[35] He gave little support to these extravagant interpretations and insisted, up to the year of his death, that his only aim was to paint "directly from nature, striving to render my impressions in the face of the most fugitive effects."[36] Yet behind Monet's brusque statements, and implicit in his obsession with more and more evanescent effects and activities of nature, one can discern a ruthlessly devaluated transcendentalism.

ROUEN CATHEDRAL

During the late winter months of 1892 and 1893, and on return visits in 1894, Monet set up his easel in the window of a shop, Au Caprice, on the second floor at 81 rue du Grand Pont, facing the square opposite Rouen Cathedral. A few canvases represent other views, but most of the more than thirty studies of the façade (page 33) were begun—if not in every case finished—from this location. Though he was not religious, Monet's choice of a motif should not be surprising. His brother lived in Rouen, less than forty miles from Giverny. Pissarro had painted there, and Monet had visited him. The Cathedral was the most famous building in upper Normandy, and Monet had painted it from the river as early as 1872.

The great façade, its rich but neutrally toned expanse of sculpture and tracery ordered by an architectural skeleton, unites the qualities of weathered Etretat cliffs with the structure of the poplars at Limetz. Facing due westward, it is a giant textured screen upon and before which an infinite range of light and atmosphere can play. Changing canvases with the hours, Monet followed the light from early morning until sunset. Even in clear weather the façade is in shade early in the day, with a bit of blue sky between the towers; that at the left, the Tour Saint-Romain, is touched by sun on the side that faces south. On misty mornings the Cathedral is barely visible across the square. Little by little as the day advances sunlight creeps over spires, colonnettes, sculpture, and tracery detail by detail until, early in the afternoon, the façade is in full sunlight. The illumination becomes warmer as the sun lowers, and as it sets behind the buildings of the city its rays weave the old stonework into a strange fabric of burnt orange and blue. Heightened by the intentness of Monet's identification, these effects were his theme. More sharply delineated in the sunset versions, the verticals of the piers accent the enduring skeleton to which the fluctuating pigmentation adheres.

Concerning the fidelity of Monet's interpretations it should be said that his vision was anything but naive by the nineties, and that a process of analytical separation, in which certain dense shadows and stains on the masonry were discarded, surely preceded the final optical synthesis. By adding white to his pigments (thus raising the color key), and by scumbles and dry glazes, Monet was able to disentangle the transparent film of light from the surface beneath it.

The inclusion of twenty Cathedrals in Monet's exhibition at the Durand-Ruel Gallery in 1895 stimulated an avalanche of comment, most of it rhapsodic. Monet's friend Georges Clemenceau, setting up as art critic "for a day," divided the series into four groups that he described as gray, white, iridescent, and blue. "With twenty pictures," he wrote, "the painter has given us the feeling that he could have . . . made fifty, one hundred, one thousand, as many as the seconds in his life. . . . Monet's eye, the eye of a precursor, is ahead of ours, and guides us in the visual evolution which renders more penetrating and more subtle our perception of the universe."[37] Less sympathetic observers were nonplussed by the bold simplicity of Monet's formal innovations. "Not enough sky around, not enough ground," complained Georges Lecomte. "... I fully understand what these Cathedrals are: *marvelously executed walls* [italics not in the original]."[38] George Moore objected to the "feat" of painting "twelve views of the cathedral without once having recourse to the illusion of distance," adding that the paint surface (which was rougher when it was new than it is today) was "that of stone and mortar," and suggesting that Monet must have "striven by thickness of paint and roughness of the handling to reproduce the very material quality of the stonework."[39]

A peak in Monet's materialization of the ephemeral is arrived at in the Cathedrals. Even in his early canvases he painted the visual curtain rather than conceptual bulk. Later on impressions were interpreted, controlled, and intensified. But gradually, as his eyes probed more deeply, as he analyzed more carefully both what he saw and his

responses to it, he painted *sensations* as well as appearances. Finally, in these works, subject, sensation, and pictorial object have all but become identical, anticipating the "façades" painted by Picasso and Braque fifteen years later.

It has often been argued that the famous series of the nineties were overly theoretical, and that they therefore constitute a decline in Monet's power. In the case of a lesser artist, indeed, such could have been the result. But the hypertension of the Rouen ordeal was broken even before the exhibition in 1895 by the trip to Norway. The scenes of fjords, of the village of Sandviken, and the series of Mount Kolsaas are a total change. Grayed in tone, and painted in a vigorous, relaxed brush which recalls that of the seventies, they have the immediacy of sketches. For Monet, each return to nature was an antidote for mannerism.

Until recently it was often forgotten that Monet was an artist of the twentieth as well as the nineteenth century. As we look back at his later work today, however, it appears anything but anachronistic. Sixty years old in 1900, his energy and inventiveness showed absolutely no signs of slackening. He had just embarked on two immense projects: a series representing the Thames river that by 1904 comprised more than one hundred canvases, and another of his water garden at Giverny that he continued to enlarge almost until his death in 1926. The next year a cycle of huge murals was installed in two oval salons, each over seventy feet long, in the Orangerie of the Tuileries (page 52). These two series – or rather, groups of series – share a new, almost romantic aura

Column 1, line 20: In the comments attributed to Georges Lecomte, the second sentence, which begins "I fully understand . . ." is in fact a related statement by Paul Signac, from whose journal both statements were drawn.

Rouen (Hôtel d'Angleterre), March 9, 1892

... I am working hard but what I have undertaken here is enormously difficult, but at the same time of very great interest. Unfortunately the weather is getting worse, which is going to interfere

Rouen, April 13, 1892

... I am absolutely discouraged and dissatisfied with what I have done here; I tried to do too well and have ended up by spoiling what was good. For four days I have not been able to work and I have made up my mind to abandon the whole thing and return home, but I don't even want to un-pack my canvases

Rouen, March 28, 1893

... My stay here goes on; that does not mean that I am close to finishing my cathedrals. Alas! I can only repeat this: that the more I continue, the more trouble I have in rendering what I per-ceive; and I say to myself that he who claims to have finished a canvas is a terrible boaster. To finish means to complete, to perfect, and I labor without advancing; searching, groping, ending up without much of anything, but at the point of being exhausted by it.

Giverny, February 20, 1894

... [I am] at the point of giving up exhibiting the cathedrals I shall write you from here at the end of the week to tell you yes or no, but I believe that it will be no. Time passes and I make no progress.

Giverny, April 20, 1894

... Nature is changing so rapidly at this moment, it is agonizing. With that, I dare not touch the cathedrals.

Excerpts from Monet's letters [40]

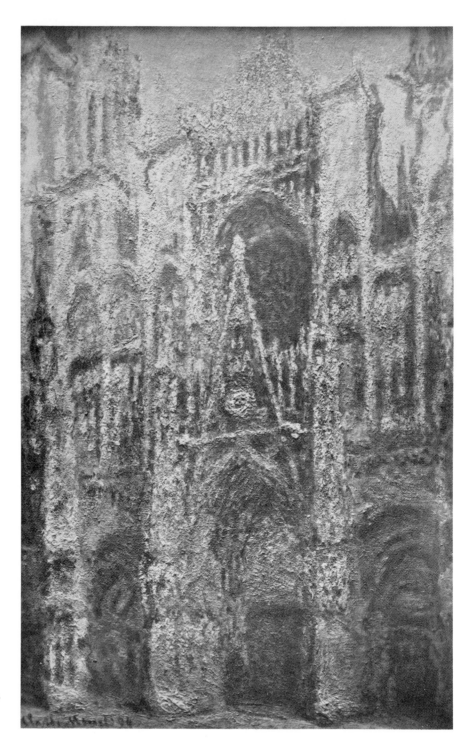

Rouen Cathedral: The Façade in Sunlight.
1894. Oil, $39^3/_8 \times 25^5/_8''$. Collection
Durand-Ruel, Paris

of mystery and indefiniteness, though in most other ways they are opposed. The "water landscapes" climax the expanding, curvilinear trend of Monet's development whereas the London riverscapes continue the geometric trend begun on the Thames in 1871.

LONDON

Monet made a painting trip to London each winter between 1899 and 1901, where he stayed at the Savoy Hotel on the Embankment. Looking downward toward the left from his fifth floor balcony he could watch the traffic on and below Waterloo Bridge against a background of smoking factory chimneys; toward his right were Charing Cross and Westminster Bridges, and behind them the Gothic Parliament buildings. These were his first two motifs. The third, the Houses of Parliament seen from across the river, was painted from the balcony of Saint Thomas's Hospital.

As Monet himself has implied (page 36), it would be inaccurate to say that his subjects were bridges, boats, or buildings. He has eloquently explained the attraction that London held for him. Before anything else he was hypnotized by the *brume* and the *brouillard*—the enveloping mantle of mist and fog within which architectural masses became weightless phantoms in the refracted sulphur, blue, or reddish light from the muffled sun. In the manifestations of the Thames Monet discovered qualities—mystery, extreme simplification, protean variability, amplitude—that he loved and sought out, but would never invent. Here he found

reality with the enigmatic beauty and melancholy of the dream. More than any other group of works, these exotic riverscapes disclose the romanticism that lay within his personality: it is evident in the Gothicizing attenuation of the Parliament towers. Not each motif, but each *apparition* has its peculiar color and key, stroke type, and tempo. Harking back to the famous *Impression* (page 54), certain of the Houses of Parliament are painted with the transparency of watercolor, in strokes directed by the drifting fog. Touched with gleams of light, water merges with air in a single medium—volume without mass.

Fascinating oddities from one of the London trips—and it should be mentioned that such "sports" can be discovered throughout Monet's career—are the two virtually abstract views of Leicester Square by night. If proof is needed that the "look" of the 1950s can be approached from either side of the line separating realism from abstraction, here it is. The unchanging illumination of Leicester Square can also serve to point out the thoroughgoing impressionist spirit of the works that make up the three major London series, completed at Giverny though many of them were. If impressionism is conceived as the representation of one in a sequence of natural aspects as it appears momentarily, Monet was more of an impressionist in 1900 on the Thames than he was in Argenteuil. As his feverish scramble for the appropriate canvas (page 36) proves, he was not representing a process of change, but painting *against* time with the goal of eternalizing the instant. A fourth dimension is added only when, in fact or imagination, we see these individual aspects multiplied.

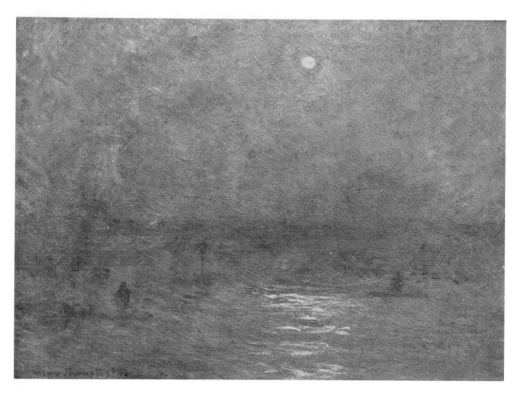

Waterloo Bridge, sun in fog. 1903. Oil, $28^3/_4 \times 39''$. The National Gallery of Canada, Ottawa

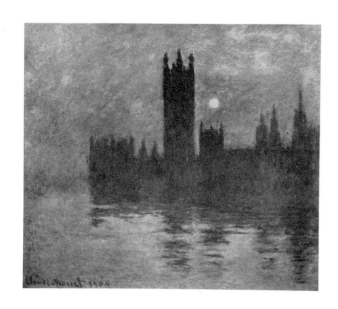

The Houses of Parliament. 1904. Oil, $31^1/_2 \times 35^3/_4''$. Kaiser-Wilhelm-Museum, Krefeld, Germany

I spent three winters in London where my son had gone to study English I love London, much more than the English countryside but I love it only in winter. In summer it is fine, with its parks, but that does not compare with the winter with the fog, for without the fog London would not be a beautiful city. It is the fog that gives it its magnificent amplitude; . . . it is a mass, an ensemble, and it is so simple: . . . its regular and massive blocks become grandiose in that mysterious mantle How could the English painters of the nineteenth century have painted bricks that they did not see – that they could not see?

Claude Monet, November 28, 1918, and February 1, 1920[41]

. . . that was on the Thames. What a succession of aspects! At the Savoy Hotel and at Saint Thomas's Hospital, from which I regarded my prospects, I would have as many as one hundred canvases under way – of a single subject. Feverishly searching among these starts, I would choose one that did not differ too much from what I saw, but in spite of everything I would modify it completely. When I had finished working I would discover, in moving my canvases, that I had overlooked just the one that would have conformed best and that had lain just under my hand.

Claude Monet, 1920[42]

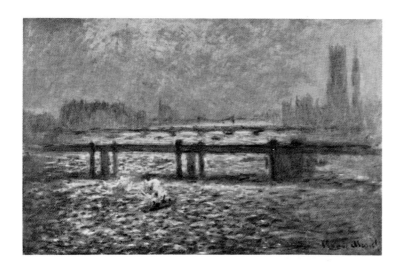

Charing Cross Bridge. (1899–1904). Oil, $24\frac{1}{2} \times 39\frac{1}{2}''$. The Baltimore Museum of Art, gift of Mrs. Abram Eisenberg

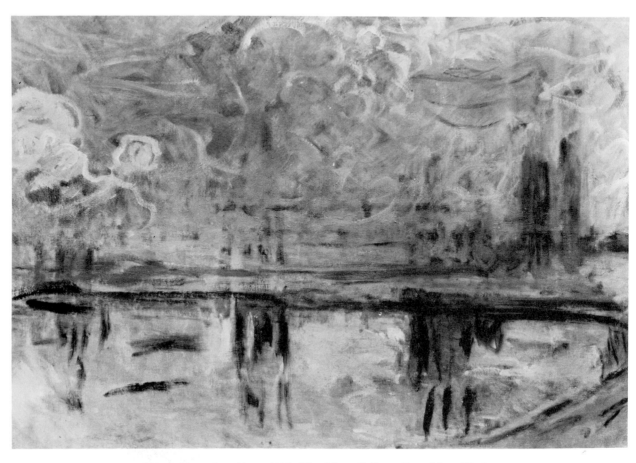

Charing Cross Bridge. (1899–1904). Oil, 25^1/$_2$ × 36^1/$_2$″. The New Gallery, Inc., New York

Morning on the Seine. 1897. Oil, $35^{1}/_{8} \times 36^{1}/_{2}''$. Collection Mr. and Mrs. Dudley S. Blossom, Jr., Cleveland

THE WATER GARDEN

No other landscape motif (except, perhaps, Cézanne's Mont Sainte-Victoire) has been subject to so close a scrutiny, has been the setting for such a range of subjective experience, or has been the source of so rich a harvest of art works as Monet's water garden. In 1890, after the purchase of the farmhouse in which he lived at Giverny, he acquired a tract of flood land that lay across the road and the one-track railroad from his front gateway. On it grew some poplars, and a tiny branch of the Epte River provided a natural boundary. Excavation was immediately begun to result, after several enlargements of the plan, in a 100 by 300 foot pond through which the flow of water from the river was controlled by a sluice at either end. Curvilinear and organic in shape, it narrowed at the western end to pass beneath a Japanese footbridge. Willows, bamboo, lilies, iris, rose arbors, benches, and on one shore curving steps leading to the water were added, providing a luxuriant setting for the spectacle of cloud reflections and water lilies floating on the pond's surface. Except for a single gate, the water garden was fenced with wire upon which rambling roses were entwined; sealed off from the outside world it formed an encircling whole; a work of art with nature as its medium, conceived not as a painting subject, but as a retreat for delectation and meditation.

The earliest study of the water garden is dated 1892, but it was not until six or seven years later that it became Monet's major subject. Something of its theme, however, is introduced in an earlier series of 1896–

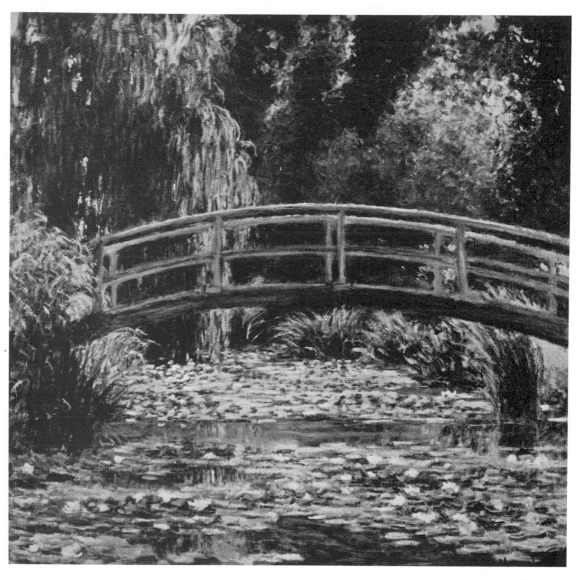

The Japanese Footbridge and the Water Lily Pool. 1899. Oil, $35^1/_4 \times 36^1/_2''$. Collection Mrs. Albert D. Lasker, New York

1897 that records, in ordered phases, the advent of dawn on the river. In the Mornings on the Seine only the faintest ripple or swell disturbs the mirroring surface between the trees; solid reality, already softened by the mist, finds its exact counterpart in the invisible water.

The twenty-seven-year period of water landscapes begins with the series of the Japanese footbridge exhibited in 1900. It was on this bridge that Monet stood to meditate and watch the lily blossoms open in the forenoon and close late in the day. Yet, because of the surrounding screen of vegetation, the effect of light is not cyclical. The first impact of these works is of an almost tropical profusion of trees, shrubs, festoons of weeping willow, and iris beds; its exotic abundance, dramatized by florid accents, is akin to the extravagant literary descriptions of Monet's friend Octave Mirbeau or the atonal music of Debussy and Stravinsky. Upon the saturated greens, blues, siennas, and ochres of the pool and its wavering reflections, the lily pads and blossoms, viewed in recession, lie like a rich but tattered carpet worked with threads of pink and white.

In the open water Monet's gardeners were kept busy pruning groups of lily pads into circular units. Searching among them his eyes found arrangements that gradually began to exclude the shore entirely. By 1903 a new relationship of space and flatness had evolved. Its patterns are open, curvilinear,

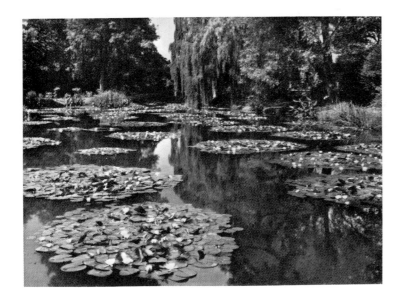

Claude Monet's water garden at Giverny. (Photograph *Country Life*, London, c. 1933)

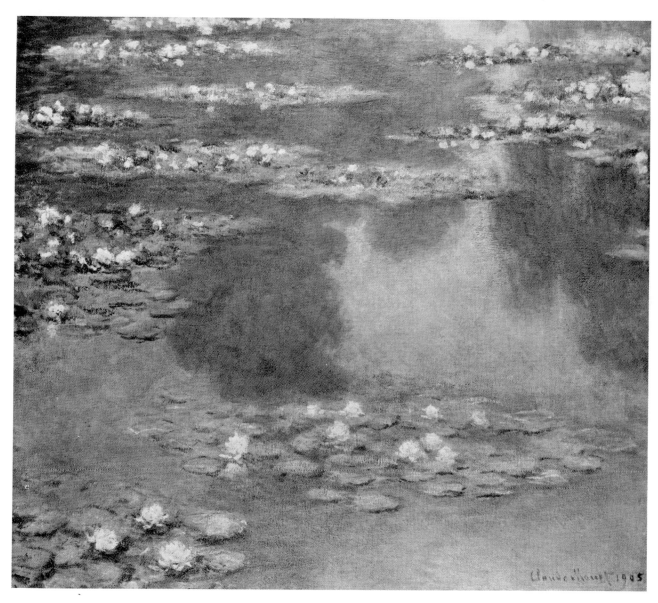

Water Lilies. 1905. Oil, 35$^1/_4$×39$^1/_4$″. Museum of Fine Arts, Boston

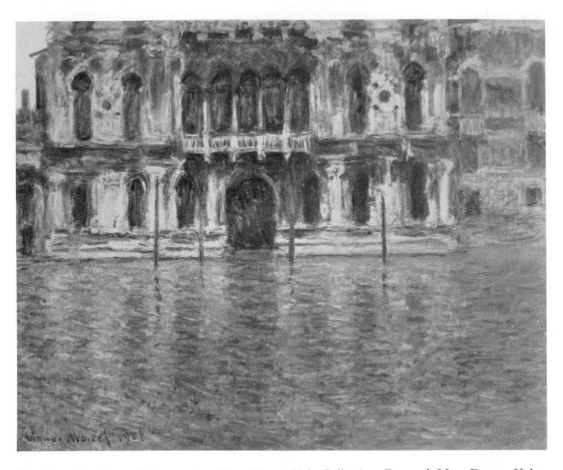

The Contarini Palace, Venice. 1908. Oil, $28^7/_8 \times 36^1/_2''$. Collection Dr. and Mrs. Ernest Kahn, Cambridge, Massachusetts

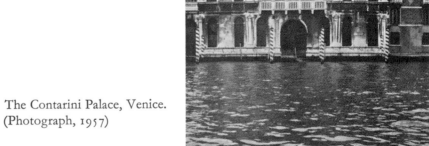

The Contarini Palace, Venice.
(Photograph, 1957)

42

and expanding, and of a random naturalness; yet the clusters are nevertheless held in mutual attraction by a geometry as nebulous as that of the clouds whose reflections passed over the pond's surface. It is surprising how little "aesthetic distance" separates these images from photographic actuality; yet in their isolation from other things, and because of the mood they elicit, they seem, like pure thought or meditation, abstract.

It is an ironic reminder of the artist's predicament that Monet found as much anguish in struggling to represent his garden as he did satisfaction in contemplating it. In August 1908, after ten years during which he painted it each summer, he wrote to Geffroy that "these landscapes of water and reflections have become an obsession. They are beyond the powers of an old man, and I nevertheless want to succeed in rendering what I perceive. I destroy them . . . I recommence them . . . and I hope that from so many efforts, something will come out."[43] Discouraged, troubled with weakening eyesight, attacks of vertigo, and fatigue, in September Monet accepted an invitation to visit Venice, where he had never been.

VENICE

Judged by the aesthetic of "instantaneity" the Venetian pictures, like many of the late works painted within the water garden, are not a true series. Monet was delighted with Venice, and regretted not having visited it earlier; but even though he extended his stay until December and returned again the following fall, most of the pictures were completed at Giverny. After many inter-

ruptions twenty-nine canvases, representing nine motifs, were shown at the Bernheim-Jeune Gallery in 1912. Except for a romantic view of San Giorgio Maggiore at twilight they share a common, generalized interpretation of the rose, blue, and violet tremolo of Venetian light. Because they were finished from memory, Monet felt that nature had "had its revenge," and he was deeply dissatisfied.[44] "I know very well in advance that you will find my canvases perfect," he wrote to Durand-Ruel before the exhibition, ". . . that they will have great success, but that makes no difference to me since I know they are bad and am certain of it."[45]

Of this bouyantly beautiful group of paintings, the close-up views of palaces are especially interesting. Ignoring romantic clichés, and advancing from the precedent of his Poplars and the Rouen Cathedrals, Monet affixed the truncated façades of the Mula, Contarini, and Dario Palaces to the tops of his compositions, square with the frame and exactly parallel to the canvas surface. The rhythmic horizontal and vertical architectural divisions reinforce the sparkle of light and shadow on the lapping water. In place of hackneyed *bizarrerie*, Monet has given us urbane formal structures; in each, the active upper portion pushes forward, while the horizontal water surface fades into the building's vertical reflection. These are the last of Monet's architectural works and the purest examples of the levitational predisposition that ties his art to that of the twentieth century. "It seems that the rose and blue façades float on the water," wrote a young French writer, Henri Genet, when the pictures were exhibited.[46]

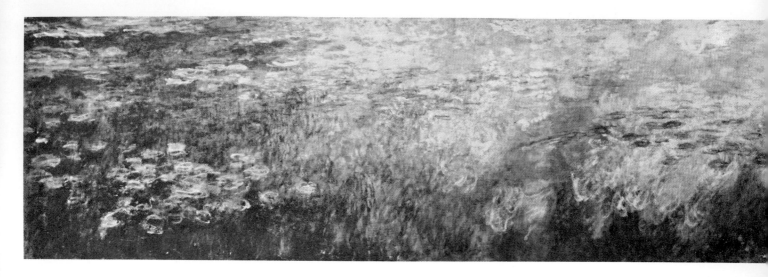

Water Lilies. (c. 1920). Oil, 6¹/₂ feet high by 42 feet long. The Museum of Modern Art, New York, Mrs. Simon Guggenheim Fund

We entered his studio with an emotion comparable to that felt by a believer within a sanctuary. A sonorous "bonjour" greeted us, and immediately questions were pouring from Monet's lips as he showed us the extraordinary panels . . . :

"What do you think of them? 'Moi, je ne sais pas.' I cannot get a clear idea. I no longer sleep because of them. In the night I am constantly haunted by what I am trying to realize. I rise broken with fatigue each morning. The coming of dawn gives me courage, but my anxiety returns as soon as I put foot in my studio. 'Moi, je ne sais pas.' Painting is so difficult and torturing. Last autumn I burned six canvases along with the dead leaves from my garden. It is enough to make one give up hope. Nevertheless I should not like to die before having said everything that I had to say— or at least having tried to say it. And my days are numbered Tomorrow, perhaps"

From an account of a visit to Giverny in 1924,
two years before Monet's death [47]

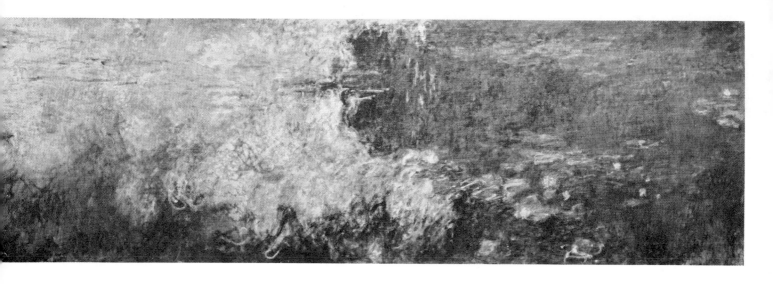

THE WATER LANDSCAPES

After he returned from his first Venice trip in 1908 Monet saw his canvases of the water garden with a "better eye," and began choosing from them for an exhibition to be called *Les Nymphéas: série de paysages d'eau.*[48] Forty-eight, dated between 1903 and 1908, were shown in May 1909 at the Durand-Ruel Gallery.

The conception of an ovoid salon decorated with water landscapes probably entered Monet's mind (if he had not thought of it earlier) at this time. During the eighties he had experimented with enlarging landscapes to mural size, and combining small panels in a decorative scheme; but the enlargements lost their impressionist immediacy and the combinations lacked unity. In the water garden, however, he had already created a motif for which such a room would be the ideal equivalent. It was apparent, moreover, that the individual canvases of water lilies, though carefully composed and therefore satisfying in themselves, were also fragments that begged to be brought together in an encompassing whole. Reviewing the 1909 exhibition in the *Gazette des Beaux-Arts*, the critic Claude Roger-Marx included an "imaginary" conversation in which Monet spoke thus: "I have been tempted to employ this theme of *Nymphéas* in the decoration of a salon: carried along the walls, its unity, unfolding all the panels, would have given the illusion of an endless whole, of water without horizon or bank; nerves tense from work would be relaxed there . . . and to him who lived there, that

45

room would have offered the refuge of a peaceable meditation in the center of a flowering aquarium."[49]

Such a project was without precedent, an ambitious one even for a young man, and by 1912 when the Venetian series was finished Monet was over seventy, with a film already forming over one eye, and despondent over the death of his second wife. "After the calamity of my life," Monet later recalled, "and after my illness, I had ceased to paint. Since the views of Venice, shown at Bernheim's, I had done nothing."[50] Only one small group of works, the Flowering Arches of 1913, can be associated with this period.

In 1914 came the war and the death of his son Jean. Still in mourning, Monet was visited by his most intimate friend, Clemenceau, to whom he spoke nostalgically of the decoration he would have undertaken had he been younger. "It is superb, your project! You can still do it." was Clemenceau's reply.[51] Monet's resolve was also strengthened when a lady admirer wrote suggesting "a room almost round that you would decorate and that would be encircled by a beautiful horizon of water."[52] Plans were immediately begun for a huge studio that was finished, in spite of war shortages of material and labor, by 1916. Meanwhile Monet had already begun working around the lily pool on large canvases that were placed on a specially constructed easel by one of the gardeners and replaced when the light changed. By 1917 the plan, in its first phase, was well under way, and at Giverny in November (it is said on November 18th, the day allied troops entered Strasbourg) the "Tiger of France," Clemenceau, accepted Monet's offer of a commemorative gift to the state of a group of water landscapes.[53]

The next year, when Monet was visited by the art dealers Georges Bernheim and René Gimpel (who had heard gossip about an "immense and mysterious decoration on which the artist worked") they saw assembled in the new studio "a strange artistic spectacle: a dozen canvases placed in a circle on the floor, one beside the other, all about two meters [78³/₄″] wide and one meter twenty [47¹/₄″] high; a panorama made up of water and lilies, of light and sky. In that infinitude, water and sky have neither beginning nor end. We seem to be present at one of the first hours in the birth of the world. It is mysterious, poetic, delightfully unreal; the sensation is strange; it is a discomfort and a pleasure to see oneself surrounded by water on all sides."[54] There were about thirty of these panels in all.

In 1919, with neither the final form nor the location of the proposed decoration determined, Monet began to work on larger panels, within the studio; in 1920 he discussed his ideas, still in flux, with the Duc de Trévise. "It seems to me," . . . the Duke said, "that the owner of one of your series would have nothing to complain about. He would not need great imagination to erect a spacious pantheon in his park in which to house them; above them would reign the calm gray of the walls, crowned at the top by some flowering frieze...." "That is exactly my idea," Monet broke in; "I am composing it with wisteria."[55] It is possible that *Wisteria* was one of these studies (page 49). Rapidly sketched and sparkling, its brushstroke is like the crack of a whip: what young abstractionist of the fifties could paint with

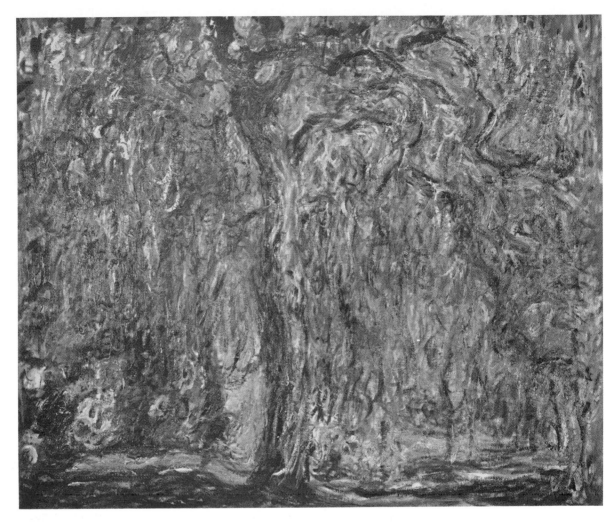

Weeping Willows. (1918). Oil, 39$^1/_2$ × 47$^1/_2$". Collection Mr. and Mrs. David Rockefeller, New York

Monet worked on the "Weeping Willow" motif in
1918, and certain versions bear that date. The canvas
illustrated on page 47, however, is signed and dated
1919, as indicated in the catalogue list, page 63.

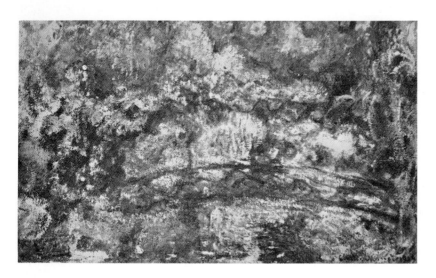

The Japanese Footbridge. 1919. Oil, $25^{1}/_{2} \times 42^{1}/_{8}''$. Collection Sam Salz, New York

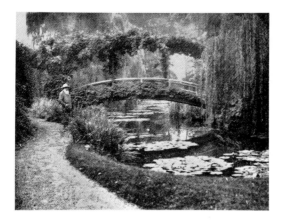

Claude Monet in his water garden. (Photo Viollet)

more fire and zest? It was in 1920, also, that Monet spoke of his intention to donate to the Hôtel Biron (The Rodin Museum) "twelve of my latest decorative canvases of which each measures four meters twenty [just under fourteen feet]."[56] It is mainly canvases of this size that make up the murals in the Orangerie of the Tuileries.[57]

Since 1917, however, the cataracts on Monet's eyes had become constantly worse, and he was obliged to wear heavy glasses. "I see much less well," he complained to M. Gimpel; "I am half blind and deaf."[58] He worked in a broader style, with long, flexible brushes. "I am passionately fond of this work on large canvases," he explained; "last year I tried to paint on small canvases, and not very small: impossible; I cannot do it any more because today I am used to painting broadly and with large brushes."[59] His color vision was also affected, but it would be as false to undervalue the late outdoor studies for their altered visualization as it would be to dismiss Beethoven's last quartets because of his deafness. Dated canvases–of which there are few after 1908– like the magnificent *Japanese Footbridge* of 1919 show how great Monets's powers still were. None of his early works have such opulence of surface and unity of color. The rich pigmentation–superbly-worked greens, golden siennas and ochres lit with pink and yellow–raises in a tactile relief that is both illusory and actual. Like a late painting by Rembrandt, it seems aglow with an inner illumination.

The Japanese footbridge had a special significance for Monet. It was the first spot in the garden that, in 1892, he elected to paint, and was the subject of the first group

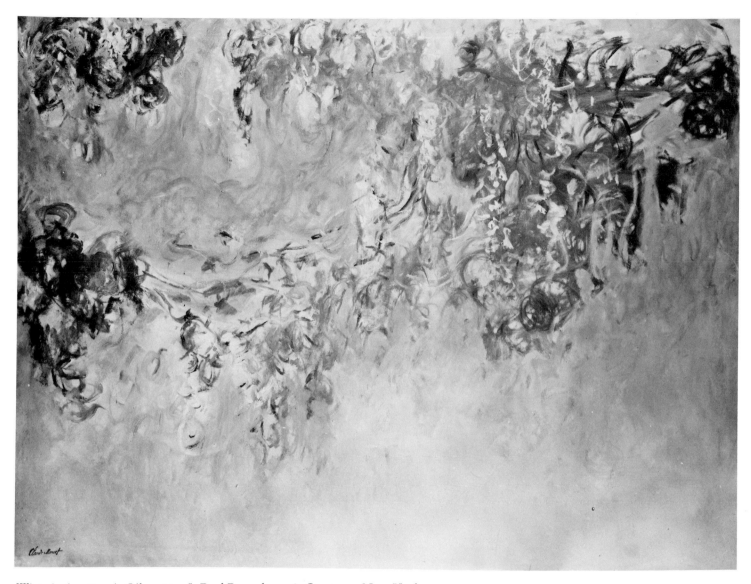

Wisteria. (1918–20). Oil, 59 × 79″. Paul Rosenberg & Company, New York

of water landscapes shown in 1900. Almost hidden by hanging wisteria, it was also the subject of the last series before virtual blindness stopped his work early in the fall of 1922. The decision to place the large decoration in the Orangerie had been approved the previous year, and Monet had brought the individual panels close to completion. Somehow, when working on the decorations in the studio, Monet was able to maintain his color scheme by familiarity with a controlled range already established, but outdoors he was forced to rely on vision he knew to be distorted. "How do you see that?" he would ask at the table, fiercely indicating his dinner plate; "I see it yellow."[60] During the tragic summer of 1922, fearful of ruining the water landscapes if he continued to work on them, he went into the garden seized, as Louis Gillet has recalled, by a demon of work, and returned to the footbridge motif that had first attracted him in 1892. "He painted . . . wild landscapes of a more and more feverish aspect; hallucinated, in impossible color schemes, all red or all blue, but of a magnificent aspect. The claw of the lion could always be felt."[61] Thus the long sequence of Japanese Footbridge canvases comprises a new kind of series, tracing moments of physiological and emotional, as well as natural, metamorphosis; from impressionism to an art in which nature was re-formed according to distorted vision and inner anguish to produce Monet's only truly expressionistic works.

An operation on one eye was performed successfully in February 1923. When the bandages were removed Monet's first sensation was of a permeating blueness, and on returning home he was amazed by the odd coloration of his most recent painting. By November he was once again at work. Even at night in his dreams he concentrated on the decorations and, always dissatisfied, continued perfecting them as long as he was able: "I shall work on them until my death," he had predicted in 1920, "that will help me in passing my life."[62]

Monet was a severe critic of his own work. Knowing that everything he had touched would be preserved if he did not destroy it himself, he burned discarded canvases. At his death, nevertheless, the studios at Giverny contained a treasure of large paintings, most of them unsigned and undated, and many of them unfinished. In addition to the water landscapes these included many other motifs around the lily pool and its banks, among them a strange group of 1918 representing a jungle of weeping willows (page 47), and many superb floral studies like *Agapanthus*, *Yellow Iris*, and *Wisteria*. Most of the works of Monet's great final period lay all but forgotten for more than twenty years, and some were damaged by shells from tanks and artillery during the Nazi retreat from France. It was not until after 1950 that they were once more deemed worthy of their creator, and understood as masterpieces with a meaning for our time as well as his.

The universe that Monet discovered in the suspended quiet of his water garden, and recreated in his last canvases, reawakens dulled sensibilities by cutting perception loose from habitual clues to position,

Agapanthus. (1918–26). Oil, 79$\frac{1}{8}$×71″. Collection Mr. and Mrs. Joseph Slifka, New York

depth, and extent. It is a world new to art, ultimately spherical in its allusions, within which the opposites of above and below, close and distant, transparent and opaque, occupied and empty are conflated. Nevertheless – notably in the Museum of Modern Art's breath-taking triptych[57] – equilibrium is maintained by an indeterminate horizontal; a shadowy equator before which the surrounding globe of the sky, seen in the iridescent clouds that curve downward in an inverted image, becomes one with the water to form a common atmosphere. The pond's surface is only barely adumbrated by the unfinished constellations of lily pads that, like flights of birds, punctuate the expanding space.

In the darkness below, the life-rhythm that Monet worshipped is all but stilled. It is the tangibility of the work of art that keeps it alive–the saturated, shuttling color tones, the scraped and scumbled flatness of the canvas surface, the nervous tangles that will not retreat into illusion, and the few furtive stabs of white, yellow, pink, or lilac that we recognize as blossoms.

To Monet these final landscapes of water, like those of the Norman beaches, the Seine, or the open sea, were records of perceived reality, neither abstract nor symbolistic; but to him, from the beginning, nature had always appeared mysterious, infinite, and unpredictable as well as visible and lawful. He was concerned with "unknown" as well as apparent realities. "Your error," he once said to Clemenceau, "is to wish to reduce the world to your measure, whereas, by enlarging your knowledge of things, you will find your knowledge of self enlarged."[63]

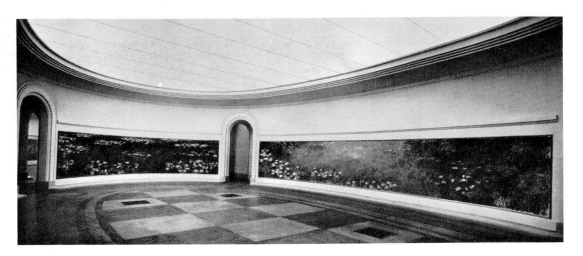

Monet's water landscapes in the Orangerie of the Tuileries, Paris

NOTES TO THE TEXT

1 Georges Jean-Aubry, *Eugène Boudin*, Paris, Bernheim-Jeune, 1922, pp. 29, 30, 35.

2 Marthe de Fels, *La vie de Claude Monet*, Paris, Gallimard, 1929, p. 25.

3 F. Thiébault-Sisson, "Claude Monet, un entretien," *Le Temps*, Nov. 26, 1900.
A translation of the same year is reprinted in *Art News Annual*, Vol. 26, 1957, p. 127 ff. Despite Monet's misstatements, it is the most complete account of his early life.

4 G. Jean-Aubry, "Une visite à Giverny," *Havre Eclair*, Le Havre, Aug. 1, 1911, p. 1.

5 Gustave Geffroy, *Claude Monet, sa vie, son temps, son oeuvre*, 1st ed., Paris, Crès, 1922, p. 295. Essay on Haystacks reprinted from exhibition catalogue, Durand-Ruel Gallery, Paris, May 1891.

6 H. Fiérens-Gevaert, *L'Indépendant*, Paris, [undated clipping] 1895.

7 Sir Kenneth Clark, *Landscape Painting*, 2nd ed., New York, Scribners, 1950, p. 94.

8 W. J. Smith, ed., *Selected Writings of Jules Laforgue*, New York, Grove, 1956, p. 192.

9 Joachim Gasquet, *Cézanne*, Paris, Bernheim-Jeune, 1921, p. 90.

10 John Rewald, *The History of Impressionism*, 2nd ed., New York, The Museum of Modern Art, 1946, p. 164.

11 Lilla Cabot Perry, "Reminiscences of Claude Monet from 1889 to 1909," *The American Magazine of Art*, Vol. 18, No. 3, March 1927, p. 120.

12 Aldous Huxley, *The Doors of Perception*, New York, Harper, 1954, p. 53.

13 July 21, 1890. Geffroy, *op. cit.*, p. 189.

14 Nov. 1, 1886. D. Rouart, ed., *Correspondance de Berthe Morisot*, Paris, Quatre-Chemins, 1950, p. 130.

15 Kervilaouen, Belle-Ile, Oct. 28, 1886. Lionello Venturi, *Les archives de l'Impressionnisme*, 2 vols., Paris, Durand-Ruel, 1939, Vol. 1, p. 320.

16 Gustave Cahen, *Eugène Boudin, sa vie et son oeuvre*, Paris, Floury, 1900, p. 181.

17 Rewald, *op. cit.*, reproduces two of the Jongkinds, pp. 100-101, and the two Monets, p. 103.

18 D. S. MacColl, *Nineteenth Century Art*, Glasgow, Maclehose, 1902, p. 163.

19 Quoted by René Gimpel [Unpublished journal], Paris.

20 Zacharie Astruc, *Les quatorze stations du Salon*, Paris, 1859, p. 249.

21 *Ibid.*, p. 303; and M. Aubert, *Souvenirs du Salon de 1859*, Paris, 1859.

22 [Salon catalogue], Paris, 1864.

23 [Salon catalogue], Paris, 1865.

24 In *l'Impressionniste*, Paris, April 6-28, 1877. See Venturi, *op. cit.*, Vol. 2, p. 312.

25 Perry, *op. cit.*, p. 120.

26 *Ibid.*, p. 121.

27 From a letter to Théodore Duret. See Charles Léger, *Claude Monet*, Paris, Crès, 1930, p. 10.

28 Guy de Maupassant, "La vie d'un paysagiste," *Oeuvres posthumes*, Paris, Conard, Vol. 2, pp. 85-86. From *le Gil Blas*, Paris, Sept. 28, 1886.

29 Duc de Trévise, "Le pélerinage de Giverny," *Revue de l'art ancien et moderne* [special edition], 1927, p. 22.

30 René Delange, "Claude Monet," *L'Illustration*, Vol. 169, No. 4378, Jan. 15, 1927, p. 54.

31 Geffroy, *op. cit.*, p. 189.

32 Wassily Kandinsky, *Rückblick 1901-1913*, Berlin, Der Sturm, 1913. See new ed., Baden-Baden, Klein, 1955. p 15.

33 Perry, *op. cit.*, p. 121.

34 Marc Elder, *A Giverny, chez Claude Monet*, Paris, Bernheim-Jeune, 1924, p. 12.

35 C. Janin, *l'Estafette*, Paris, March 10, 1892.

36 Evan Charteris, *John Sargent*, New York, Scribner's, 1927, p. 131.

37 Georges Clemenceau, *Claude Monet: The Water Lilies*, trans. George Boaz, Garden City, Doubleday, 1930, pp. 129-130.

38 John Rewald, "Extraits du journal inédit de Paul Signac," *Gazette des beaux-arts*, Series VI, Vol. 36, Nos. 989-991, July-Sept. 1949, pp. 123, 130.

39 George Moore, *Modern Painting*, enlarged ed., London, Scott, [1898], p. 248.

40 Geffroy, *op. cit.*, page 194, for the excerpt dated March 28, 1893; for the others see Venturi, *op. cit.*, Vol. 1, pp. 343, 344, 349, 350.

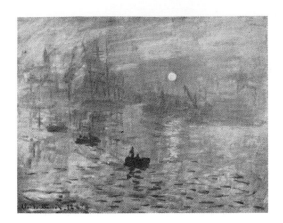

Impression—Sunrise. 1872. Oil 19½ x 25½". Musée Marmottan, Paris

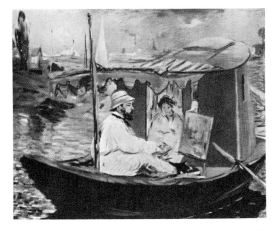

Edouard Manet: *Claude Monet in his Floating Studio.* (1874). Oil, 31½ x 38⅝". Neue Pinakothek Munich

41 Gimpel, *op. cit.*

42 Trévise, *op. cit.*, p. 22.

43 Geffroy, *op. cit.*, p. 238.

44 Fels, *op. cit.*, pp. 190-191.

45 Venturi, *op. cit.*, p. 433.

46 In *l'Opinion*, June 1, 1912. See Geffroy, *op. cit.*, p. 247.

47 Delange, *op. cit.*, p. 54.

48 Venturi, *op. cit.*, p. 419.

49 Claude Roger-Marx, "Les Nymphéas de M. Claude Monet," *Gazette des beaux-arts*, Series IV, Vol. 1, June 1909, p. 529.

50 Trévise, *op. cit.*, pp. 24-25.

51 *Ibid.*

52 *Ibid.*, p. 26.

53 Louis Gillet, *Trois variations sur Claude Monet*, Paris, Plon, 1927, pp. 77-78.

54 Gimpel, *op. cit.*

55 Trévise, *op. cit.*, p. 27.

56 Gimpel, *op. cit.*

57 The 42-foot composition (pages 44-45) acquired by The Museum of Modern Art in 1959 is plainly a variant of that opposite the entrance door in the first of the two oval rooms in the Orangerie, and it is also made up of three panels approximately 14 feet in width.

58 Gimpel, *op. cit.*

59 *Ibid.*

60 Gillet, *op. cit.*, p. 104.

61 *Ibid.*, p. 96. The strange coloration of Monet's Japanese Footbridge canvases painted between 1919 and 1922 can, it would appear, be explained thus: The earlier golden yellow versions show the change in his vision. Later, realizing that his eyes exaggerated yellow, he used less of it, but overcompensated. Green or warm-toned subjects therefore became, respectively, bluish or reddish.

62 Gimpel, *op. cit.*, p. 96.

63 Clemenceau, *op. cit.*, pp. 154-155.

BIOGRAPHICAL OUTLINE AND LIST OF MAJOR EXHIBITIONS

Exhibitions are listed in italics and appear as the last entry for the respective year.

1840 Nov. 14: Claude-Oscar Monet born in rue Lafitte, Paris, the elder son of a grocer.

1845 To improve their fortunes, the family moves to Le Havre, where Monet's father becomes the partner of his brother-in-law, M. Lecadre, a well-to-do ship chandler and grocer who lives in the suburb of Sainte-Adresse.

1855 Monet locally known for his caricatures, which he sells for as much as 20 francs.

1856– Studies drawing under Jacques François Ochard.

1858 Caricatures are exhibited in a small stationery and framing shop where Monet meets its former proprietor, Eugène Boudin, who introduces him to outdoor painting and becomes his first master. Discovers painting by Daubigny in Mme Lecadre's attic studio. *View of Rouelles exhibited in Rouen.*

1859 May: Visits Paris. In Salon, is impressed with the works of Daubigny and Troyon, who later advises him to study with Couture. Stays in Paris and works (against his family's wishes) at Charles Jacque's "free" Académie Suisse, where he meets Pissarro. Frequents (and sketches at) the Brasserie des Martyrs, where Courbet and the Realists gather.

1860 Late winter: Sees 18 works by Delacroix at a loan exhibition. Apr.: Paints landscapes at Champigny-sur-Marne. Fall: Called up for military service.

1860– Chooses to serve with the *Chasseurs d'Afrique* in
1862 Algeria. Excited by the southern light and color.

1862 Early: Sent home to Sainte-Adresse on sick leave. Monet's family agrees to buy him a substitute to complete his remaining service. Summer: Paints the coast with Boudin and meets Jongkind. Nov.: Returns to Paris with family's permission. On the advice of a relative (the academic painter Toulmouche) enters the studio of Charles Gleyre; he is unhappy with the teaching but meets Renoir, Sisley, and Bazille.

1863 Mar.: Manet exhibits at the Galerie Martinet. Easter holidays: Paints outdoors at Chailly (in the Forest of Fontainebleau) with Renoir, Sisley, and Bazille. May 15: Manet's *Déjeuner sur l'Herbe* is shown in the Salon des Refusés. Monet and Bazille watch Delacroix at work in his studio from a friend's window next door.

1864 Meets Courbet in Paris. Summer: Monet and Bazille paint in and around Honfleur. They board at Mére Toutain's Ferme Saint-Siméon. July: Bazille leaves Honfleur, but Monet stays, and later visits with his family at Sainte-Adresse. After a quarrel they cut his allowance and all but disown him. Oct.: Through Bazille he tries unsuccessfully to sell three pictures to Courbet's patron in Montpellier, Bruyas. Dec.: Without funds, he returns to Paris.

1865 Shares Bazille's studio, 6 rue de Furstenberg. Is visited by Courbet, Pissarro, and Cézanne. Apr.-Fall: Stays at the Auberge du Lion d'Or in Chailly where (in August) he works on various studies for the *Déjeuner sur l'Herbe*, with Camille Doncieux and Bazille as models. As a result of Courbet's criticism, the large composition remains unfinished, and is seized as security for debts. Fall: Works at Trouville with Boudin, Daubigny, and Courbet, and meets Whistler.
Spring: Salon (first submission). 2 marines.

1866 Spring: Portrait of Camille, painted in four days, is a great success in the Salon. Summer: Paints views of Paris from the Louvre. Rents a house at Ville d'Avray where he paints *Women in the Garden* with Camille as the only model. Visited by Courbet. Leaves Ville d'Avray after slashing 200 canvases to keep them from creditors. Fall: Paints at Sainte-Adresse, and goes to Honfleur.
Spring: Salon. "Camille" (The Woman in the Green Dress) and landscape of Chailly.

1867 Jan.-Feb.: Paints snow scenes near the Ferme Saint-Siméon. Bazille buys *Women in the Garden*, which is rejected at the Salon. June: Penniless, he leaves Camille, who is pregnant, in Paris, and goes to stay at Sainte-Adresse. July: Temporary loss of eyesight. Jean Monet is born in Paris. Fall: Monet and Renoir stay with Bazille in Paris, 1 rue Visconti.

1868 Spring: At Bonnières-sur-Seine. Wins a silver medal in the International Maritime Exposition, Le

Havre. Canvases seized by creditors, but bought for 80 francs each by M. Gaudibert, who commissions Monet to paint his wife's portrait. May: In Fécamp with Camille and Jean. Late June: Dispossessed and without money. Attempts suicide by drowning (?). Fall and Winter: Thanks to his patron, Monet lives peacefully in a house near Fécamp (probably at Etretat), and paints *Le Déjeuner* (Staedel Institute, Frankfurt). *Spring: Salon. 1 marine.*

1869 Winter: Frequents Café Guerbois, hangout of the Realist painters, writers, and critics. Rejected at the Salon. June: Settles at Saint-Michel. Aug.: Without funds and materials, is aided by Renoir; the two friends paint at La Grenouillère. Oct.: Goes to Etretat and Le Havre, then returns to Saint-Michel.

1870 Jan.: At Givry. Spring: Refused at Salon and Daubigny resigns from jury in protest. Included in Fantin-Latour's group portrait *L'Atelier des Batignolles*. June 26: Marries Camille. Summer: Works with Boudin at Trouville. July 19: War declared against Germany. Sept.: Leaves for London alone. Nov. 2: Bazille is killed in action. *The German Gallery (Durand-Ruel), 168 New Bond Street, London. The first exhibition of the Society of French Artists. 1 work. Between 1870 and 1874 Monet showed several times with this group.*

1871 Jan.: Introduced to Paul Durand-Ruel by Daubigny. With Pissarro, sees works by English painters in London museums. Summer: Paints in Holland. Discovers (?) and buys Japanese prints. Paints in Antwerp. Winter: In Paris. Dec.: Rents a house at Argenteuil. *International Exhibition, South Kensington Museum, London. 2 works.*

1872 Spring: Paints in Le Havre. Summer: Returns to Holland. Renoir paints with Monet at Argenteuil.

1873 Meets, and is financially assisted by, Caillebotte. Outfits a floating studio, following the example of Daubigny's *botin*.

1874 Summer: Manet (staying at Gennevilliers, across the river) works with Monet and Renoir at Argenteuil. Monet paints in Le Havre. *Apr.-May: 1st impressionist group exhibition, 35 Boulevard des Capucines. 5 oils, 7 pastels.*

1875 Winter: Paints snow scenes in Argenteuil. Financial difficulties. Mar. 24: Disastrous auction of impressionist paintings at Hôtel Drouot. June:

Appeals to Manet for a loan.

1876 Winter: Through Cézanne meets the collector Victor Chocquet. Spring: Meets John Sargent. Summer: Returns to Argenteuil, then visits the financier and collector Ernest Hoschedé at the Chateau de Montgeron. Winter: Back in Paris, begins Gare Saint-Lazare series. *Apr.: 2nd impressionist group exhibition, 11 rue Le Peletier. 18 works.*

1877 Summer: Second stay with the Hoschedés. Fall and Winter: In desperate financial straits in Paris, solicits aid from his patrons and friends. *Apr.: 3rd impressionist group exhibition, 6 rue Le Peletier. 31 works.*

1878 Jan.: Rents a house at Vétheuil, financially assisted by Manet. Mar.: Birth of Michel Monet at 26 Rue d'Edimbourg. Spring: Publication of Théodore Duret's *Les peintres impressionnistes*. Hoschedé, financially ruined, sells collection. Summer: Mme Alice Hoschedé and children join the Monets at Vétheuil.

1879 Paints riverscapes. Sept.: Death of Camille. Paints the frozen, flooded, and thawing Seine (1879-81). *Apr. 10-May 11: 4th impressionist group exhibition, 28 avenue de l'Opéra. 29 works.*

1880 Apr.: Monet, Renoir, and Sisley, after a quarrel with Degas because they participate in the Salon, do not show in the 5th group exhibition. Summer: Begins regular painting trips to the coast (1880-86). *Salon: 1 work accepted, 1 rejected (never again submits). June: Offices of review "La vie moderne," 7 boulevard des Italiens. 18 works. Preface by Théodore Duret.*

1881 Mar.: Paints at Fécamp. Apr.: Does not show in 6th impressionist group exhibition. Fall: Paints near Trouville. Nov.: Leaves Vétheuil, spends a short time in Paris, 20 rue Vintimille, and moves to Poissy in December.

1882 Feb.-May: Works at Dieppe, Pourville, and Varengeville. May: Visits Poissy. June-Oct.: Back in Pourville with his family. Oct.: After a visit with his brother in Rouen, he returns to Poissy. *Mar.: 7th impressionist group exhibition, 251 rue Saint-Honoré. 35 works listed in catalogue.*

1883 Jan.-Feb.: Paints in Le Havre and Etretat. Apr. 30: Death of Manet. Moves to Giverny. Oct.: Visits Pissarro in Rouen. Dec. 10-26: Trip to Riviera with Renoir; they visit Cézanne. *Mar. 1-25: Durand-Ruel, 9 boulevard de la Madeleine. 56 works.*

1884 Jan.-Apr.: Returns to the Riviera alone and paints at Bordighera, Dolce Acqua, Ventimiglia (all in Italy) and Menton. Aug.: Paints at Etretat.
Apr.: Galerie Georges Petit, 8 rue de Sèze. 3rd International Exhibition.

1885 Mar.: Works on floral decoration for Durand-Ruel apartment. Oct.-Dec.: Paints at Etretat.
May: Galerie Georges Petit, 4th International Exhibition. 10 works.

1886 Spring: Beginning of monthly dinners of the Impressionists at Café Riche (Monet, Pissarro, Duret, Renoir, Mallarmé, Huysmans). Does not participate in the 8th (and last) group exhibition. Apr.-May: Third visit to Holland. Summer: Returns to outdoor figure painting. Sept.-Nov.: Visits Etretat again, then paints rocks at Belle-Ile, where he meets his future biographer, Gustave Geffroy. Late Nov.: Visits Octave Mirbeau on the Island of Noirmoutier.
Apr.-May: American Art Association and National Academy of Design, New York. Large impressionist exhibition sponsored by Durand-Ruel. 50 works. Spring: Société des XX, Brussels. 10 works.
May-July: Galerie Georges Petit. 5th International Exhibition. 13 works.

1887 *May: Galerie Georges Petit. 6th International Exhibition. 15 works including Belle-Ile views.*
May-June: National Academy of Design, New York. Durand-Ruel's second impressionist exhibition.

1888 Jan.-Apr.: Paints at Antibes and Juan-les-Pins. July: Visits London. Admired by Mallarmé.
July: Boussod and Valadon Gallery, 19 boulevard Montmartre (managed by Theo van Gogh). 10 Antibes landscapes.

1889 Jan.: With Geffroy, visits Maurice Rollinat at Fresselines (Creuse). Mar.-May: Returns to paint the Creuse. Fall: Organizes a subscription to buy Manet's *Olympia* in order to present it to the French nation.
Feb.: Boussod and Valadon.
Spring: Goupil Gallery, London. 20 works.
Shows again in Brussels (Société des XX).
June: Galerie Georges Petit. Huge Monet-Rodin Exhibition. Catalogue lists 145 works by Monet in chronological order. Preface by Octave Mirbeau.

1890 Works on paintings in series. Buys house and property at Giverny and soon begins work on a water garden.

1891 Jan.: Paints floating ice on the Seine. Dec.: Visits London and determines to return there to paint.
May: Durand-Ruel, 11 rue Le Peletier. 22 works including 15 Haystacks. Preface by Gustave Geffroy.

1892 Feb.-Apr.: Begins painting Cathedrals from second-floor window at 81 rue du Grand-Pont, Rouen. Summer: Marries Mme Hoschedé, whose daughter Suzanne marries Theodore Butler.
Feb.-Mar. 10: Durand-Ruel. 15 works including 6 Poplars.

1893 Paints ice on the Seine again. Feb.-Mar.: Continues Cathedrals in Rouen. Feb.: Discouraged, considers abandoning Cathedrals.

1895 Late Jan.-Apr.: Visits Norway; paints fiords, Mount Kolsaas, and the village of Sandviken. June: Rest cure at Sailies-de-Béarn, in the Pyrenees.
May 10-31: Durand-Ruel. 50 works including 20 Cathedrals.

1896 Mar.: Begins projected circuit of previous motifs, painting at Pourville, Dieppe, and Varengeville. Later: Paints Mornings on the Seine (1896-97).

1897 Jan.-Mar.: Paints at Pourville. Summer: Monet's son Jean marries Blanche Hoschedé.
Feb.: Exhibition in Stockholm.
Summer: Second Biennale in Venice. 20 works.
June: Galerie Georges Petit. 61 works including Cliffs at Pourville and Mornings on the Seine.

1899 Summer: Begins 27-year cycle of Water Landscapes at Giverny. Autumn: Begins the Thames series from the Savoy Hotel in London.
Apr.: Durand-Ruel. Group exhibition. 36 works.

1900 Feb.: Continues Thames series. Visited in London by Clemenceau and Geffroy. Summer: Paints Seine at Vétheuil (1900-01) once more. Temporary loss of sight in one eye from an accident.
Nov. 22-Dec. 15: Durand-Ruel. 26 works including 17 Water Lilies.

1901 Feb.-Apr.: Works in London. Later at Giverny, when not painting outdoors, develops London paintings from memory (until April 1904).

1902 Late Feb.: Visits Brittany.
Feb. 21-28: Bernheim-Jeune, 8 rue Lafitte. 6 views of Vétheuil.

1904 Apr.: Finishes London pictures after more than four years. Summer: Paints Water Lilies. Oct.: Having bought an automobile in 1903, he drives to Madrid with his wife to see Velazquez' works in the Prado. Dec.: Unsuccessful visit to London to arrange an exhibition of the Thames paintings.

May 9-June 4: Durand-Ruel. 37 Thames River views (1900-04). Preface by Octave Mirbeau.

1905 Jan.: Works on more Thames views from memory, hoping to exhibit them in London. Summer: Paints Water Lilies.
Feb.: Grafton Galleries, London. Large impressionist exhibition sponsored by Durand-Ruel. 55 works.

1906 Unsatisfied with progress in painting water garden.
Mar. 19-31: Durand-Ruel. 17 works from the Faure Collection.

1908 Spring: Troubled with illness and failing vision. Sept.-Dec.: Visits Venice with his wife; resides first, as a guest, at Palazzo Barbaro (owned by Mr. Curtis, a friend of Sargent) and then at the Grand Hotel Britannia. Enchanted by Venice, he paints with renewed enthusiasm.

1909 Jan.: Refreshed, continues work on Water Lilies. Autumn: Second trip to Venice.
May 6-June 5: Durand-Ruel. 48 Water Lilies (1903-08).

1911 May 19: Death of Mme Monet.

1912 Finishes Venetian pictures from memory. July: Visits an eye specialist in Paris.
May 28-June 8: Bernheim-Jeune, 15 rue Richepanse. 29 views of Venice. Preface by Octave Mirbeau, "Les 'Venise' de Claude Monet."

1913 Jan.: Depressed and displeased with his work. Summer: Paints floral arches in his water garden.

1914 Feb. 10: Death of Jean Monet; his widow, Blanche Hoschedé, becomes Monet's housekeeper and constant companion.
Mar. 2-21: Durand-Ruel. 48 works.

1914- Monet is encouraged by Clemenceau to undertake
1916 a group of mural-sized water landscapes. Builds a new studio, some 39 x 75 feet large and 49 feet high (12 x 23 x 15 meters) and stocks it with large canvases. From this time on he works constantly (when he is able) on canvases related to this project. Paints three self portraits and destroys two.

1917 Oct.: Visits Honfleur, Le Havre, Etretat, Yport, Pourville, and Dieppe. Summer: Paints water garden.

1918 Nov. 12: Monet asks Clemenceau to offer two canvases to the State on his behalf to commemorate the Armistice.

1919 Summer: Works on series (about 1919-22) of the Japanese footbridge. Sight failing, but Monet fears an operation.

1920 Oct.: Plans to give 12 canvases, each almost 14 feet wide (4.20 meters) to the State, to be housed in a pavilion to be erected in the garden of the Hôtel Biron (Rodin Museum). This plan later abandoned for a location in the Orangerie of the Tuileries.

1921 Apr.: Monet, Paul Léon, and Georges Salles formalize donation at a meeting in Vernon, near Giverny. Winter: Works with architect on revisions of the Orangerie building. Oct.: Visits the seashore.
Jan. 21-Feb. 2: Bernheim-Jeune. Preface by Arsène Alexandre.

1922 Summer: Almost blind from double cataracts, but works outdoors in desperation on strangely colored landscapes, trying to "paint everything before I can no longer see anything at all." Sept.: Forced to abandon work.

1923 Feb.: Cataract operation partially restores sight in one eye. Nov.: Back at work on Orangerie murals.

1924- Although he sees almost no one, he continues to
1925 paint both outdoors and on his murals when he is able. Crises of sadness, discouragement, and anxiety.

1926 Dec. 5: Monet dies at Giverny. Clemenceau, Bonnard, Roussel, and Vuillard are pallbearers at his simple funeral.

1927 May 17: Dedication of murals in the Orangerie of the Tuileries.

1928 *Jan. 6-19: Durand-Ruel, 37 avenue Friedland. 84 works. Feb.: Galerie Thannhauser, Berlin.*

1931 *Musée de l'Orangerie, Paris. 128 works. Preface by Paul Jamot.*

1936 *Apr. 2-30: Galerie Rosenberg, Paris. Preface by Albert Charpentier.*

1940 *Jan. 30-Feb. 21: Galerie André Weil, Paris. Musée de l'Orangerie, Paris, Monet-Rodin Centennial.*

1945 *Apr.-May: Wildenstein & Co., New York. 83 works. Preface by Daniel Wildenstein.*

1952 *May 10-June 15: Kunsthaus, Zurich. 126 works. Preface by George Besson. June 19-July 17: Galerie Wildenstein, Paris. 75 works. Preface by Daniel Wildenstein.*
July 24-Sept. 22: Gemeentemuseum, The Hague. 90 works. Preface by George Besson.

1954 *June-July: Marlborough Fine Art Ltd. London. 53 works.*

1956 *June: Galerie Katia Granoff, 13 Quai de Conti, Paris.*

58

Oct.: *Water Lilies. M. Knoedler & Co., New York. Late works.*

1957 *May: Galerie Katia Granoff, "L'Etang Enchanté de Claude Monet." Summer: Arts Council of Great Britain: The Royal Scottish Academy, Edinburgh (Aug. 18- Sept. 7) and The Tate Gallery, London (Sept. 26- Nov. 3). 114 works. Preface by Douglas Cooper and biographical chronology by John Richardson. Bibliography.*
Fall and winter: City Art Museum of St. Louis (Sept. 25-Oct. 22) and The Minneapolis Institute of Arts (Nov. 1-Dec. 1). Preface by William C. Seitz.

1959 *May 22-Sept. 30: Durand-Ruel, Paris. 58 works. Preface by Claude Roger-Marx.*

LENDERS TO THE EXHIBITION

Larry Aldrich, New York; Mr. and Mrs. Walter Bareiss, Greenwich, Connecticut; Mr. and Mrs. L. M. Battson, Beverly Hills, California; Mr. and Mrs. Dudley S. Blossom, Jr., Cleveland, Ohio; Mr. and Mrs. Bernard F. Combemale, New York; H. E. Coombe, Cincinnati, Ohio; Miss Marion E. Fitzhugh, New York; Edward Gilbert, New York; Mr. and Mrs. Charles Goldman, New York; Miss Adelaide Milton de Groot, New York; Mr. and Mrs. Henry J. Heinz, 2nd, Pittsburgh, Pennsylvania; Mr. and Mrs. Reinaldo Herrera, Caracas; Mr. and Mrs. Werner E. Josten, New York; Dr. and Mrs. Ernest Kahn, Cambridge, Massachusetts; M. and Mme Robert Kahn-Sriber, Paris; Mr. and Mrs. Hugh N. Kirkland, Santa Barbara, California; Dr. Ralph André Kling, New York; Mrs. Albert D. Lasker, New York; The Hon. Christopher McLaren, London; Mr. and Mrs. Erik Meyer, Copenhagen; Michel Monet, Sorel-Moussel, France; Jerome Ohrbach, Los Angeles, California; Mrs. Oliver Parker, London; The Rev. Theodore Pitcairn, Bryn Athyn, Pennsylvania; Mr. and Mrs. Joseph Pulitzer, Jr., St. Louis, Missouri; Paulette Goddard Remarque, New York; Mr. and Mrs. Edward G. Robinson, Beverly Hills, California; Mr. and Mrs. David Rockefeller, New York; Mr. and Mrs. Josef Rosensaft, New York; Baron and Baroness Philippe de Rothschild, Paris; Mr. and Mrs. John Barry Ryan, New York; J. C. W. Sawbridge-Erle-Drax, Ashford, England; Mr. and Mrs. George Lawrence Simmonds, Highland Park, Illinois; Mr. and Mrs. Joseph Slifka, New York; Mrs. N. B. Spingold, New York; Mrs. A. Lewis Spitzer, New York; Mr. and Mrs. Roger L. Stevens, New York; Mr. and Mrs. Reese H. Taylor, San Marino, California; Mr. and Mrs. J. K. Thannhauser, New York; Mr. and Mrs. Mahlon B. Wallace, Jr., St. Louis, Missouri; Ambassador and Mrs. John Hay Whitney, London;

J. H. Whittemore Company, Naugatuck, Connecticut; Mr. and Mrs. William Coxe Wright, St. Davids, Pennsylvania.

Atlanta Art Association, Georgia; The Baltimore Museum of Art, Maryland; Walters Art Gallery, Baltimore, Maryland; National-Galerie, Berlin, Federal Republic of Germany; Museum of Fine Arts, Boston, Massachusetts; Albright Art Gallery, Buffalo, New York; Fogg Art Museum, Harvard University, Cambridge, Massachusetts; The National Gallery of Wales, Cardiff; The Art Institute of Chicago, Illinois; The Cleveland Museum of Art, Ohio; Dallas Museum of Fine Arts, Texas; Denver Art Museum, Colorado; National Gallery of Scotland, Edinburgh; Gemeentemuseum, The Hague, The Netherlands; Wadsworth Atheneum, Hartford, Connecticut; Kaiser-Wilhelm-Museum, Krefeld, Federal Republic of Germany; The Trustees of The Tate Gallery, London; Musée des Beaux-Arts, Lyon, France; The Currier Gallery of Art, Manchester, New Hampshire; Musée des Beaux-Arts, Nantes, France; The Brooklyn Museum, New York; The Metropolitan Museum of Art, New York; The Museum of Modern Art, New York; Allen Art Museum, Oberlin College, Oberlin, Ohio; The National Gallery of Canada, Ottawa; Rijksmuseum Kröller-Müller, Otterlo, The Netherlands; Musée du Louvre, Paris; Musée du Petit Palais, Paris; Philadelphia Museum of Art, Pennsylvania; Carnegie Institute, Pittsburgh, Pennsylvania; The Rochester Memorial Art Gallery, New York; City Art Museum of St. Louis, Missouri; The Toledo Museum of Art, Ohio; Worcester Art Museum, Massachusetts.

Durand-Ruel, Paris; Mme Katia Granoff, Paris; The New Gallery, Inc., New York; Sam Salz, New York.

CATALOGUE OF THE EXHIBITION

Chronological listing has been interrupted when necessary in order to group works by locality and series. Dates enclosed in parentheses do not appear on the paintings. Wherever discrepancies in dates and dimensions occur between captions and this catalogue, the more recent information is incorporated here. In dimensions, height precedes width. Paintings exhibited either in New York or Los Angeles only are indicated by (N.Y.) and (L.A.). Works marked with an asterisk are illustrated.

SAINTE-ADRESSE

1 *The Beach at Sainte-Adresse.* (c. 1865). Oil, 17 x 25¾". Collection Mr. and Mrs. David Rockefeller, New York

* 2 *The Terrace at the Seaside, Sainte-Adresse.* (1866). Oil, 38 x 51". Collection The Reverend Theodore Pitcairn, Bryn Athyn, Pa. (N.Y.) Ill. p. 12

* 3 *View of Le Havre from Sainte-Adresse.* (1868). Oil, 23½ x 31½". Carnegie Institute, Pittsburgh. Ill. p. 11

4 *The Beach at Honfleur.* (c. 1865). Oil, 23½ x 32". Collection Mr. and Mrs. Reese H. Taylor, San Marino, California. (L.A.)

5 *Quai du Louvre, Paris.* (c. 1866). Oil, 25½ x 36¼". Gemeentemuseum, The Hague

6 *Argenteuil: River with Figures.* (c. 1868?). Oil, 21½ x 29". Collection Mr. and Mrs. Hugh N. Kirkland, Santa Barbara. (N.Y.). Although signed "Claude Monet 76" at the lower right, style, mood, and subject conform to the works of 1868-1869 rather than to those of 1872-1877 when Monet painted at Argenteuil, though it is not impossible that he worked there earlier.

* 7 *The Seine at Bougival.* (1869). Oil, 25 x 36". The Currier Gallery of Art, Manchester, New Hampshire. Ill. p. 7

TROUVILLE

8 *On the Beach, Trouville.* 1870. Oil, 15 x 18½". Collection Ambassador and Mrs. John Hay Whitney, London

9 *The Beach at Trouville (Hôtel des Roches Noires).* (1870). Oil, 20½ x 25¼". The Ella Gallup Sumner and Mary Catlin Sumner Collection, Wadsworth Atheneum, Hartford. (N.Y.)

HOLLAND

10 *Canal at Zaandam.* (1871-72). Oil, 16½ x 29½". Collection Mrs. A. Lewis Spitzer, New York. (N.Y.)

11 *Windmills in Holland.* (1871-72). Oil, 16 x 28½". Walters Art Gallery, Baltimore. (L.A.)

ARGENTEUIL

12 *Argenteuil.* (1872). Oil, 23½ x 31⅞". Collection Mr. and Mrs. Bernard F. Combemale, New York. (N.Y.).

13 *Madame Monet in a Red Capeline.* (c. 1872). Oil, 39½ x 31½". The Cleveland Museum of Art, Leonard C. Hanna, Jr. Bequest

14 *The Floating Studio.* (1874). Oil, 19¾ x 25¼". Rijksmuseum Kröller-Müller, Otterlo. (N.Y.)

15 *The Bridge at Argenteuil.* (c. 1874). Oil, 21 x 28½". Collection Jerome Orbach, Los Angeles. (L.A.)

16 *Snow Effect at Argenteuil.* (c. 1875). Oil, 22 x 25¾". Private collection, New York

SAINT-LAZARE STATION

* 17 *Saint-Lazare Station.* (1876-77). Oil, 21 x 28½". Collection The Hon. Christopher McLaren, London. Ill. p. 15

18 *Saint-Lazare Station.* 1878. Oil, 23¾ x 31½". Collection Mr. and Mrs. David Rockefeller, New York

VETHEUIL-LAVACOURT

19 *Winter in Vétheuil.* (1878). Oil, 23½ x 39½". Albright Art Gallery, Buffalo

* 20 *Entrance to the Village of Vétheuil: Snow.* (c. 1878). Oil, 23¾ x 31⅞". Museum of Fine Arts, Boston. Ill. p. 14

* 21 *Entrance to the Village of Vétheuil.* (c. 1878). Oil, 19½ x 24". Collection Mrs. N. B. Spingold, New York. Ill. p. 14

22 *The Seine at Lavacourt.* 1880. Oil, 39⅛ x 58¾". Dallas Museum of Fine Arts, Munger Fund Purchase. (N.Y.)

23 *Sunset on the Seine at Lavacourt, winter.* 1880. Oil, 39¾ x 59". Musée du Petit Palais, Paris. (N.Y.)

24 *Vétheuil-sur-Seine.* 1880. Oil, 23⅝ x 39⅜". National-Galerie, Berlin, Federal Republic of Germany

25 *The Break-up of the Ice at Lavacourt.* 1880. Oil, 17¾ x 32". Collection J. C. W. Sawbridge-Erle-Drax, Ashford, England

26 *The Seine at Vétheuil.* (c. 1880). Oil, 18 x 24". Collection Miss Marion E. Fitzhugh, New York. (L.A.)

27 *The Church at Vétheuil.* (c. 1880). Oil, 17 x 27½". Musée du Louvre, Paris

28 *The Seine at Vétheuil.* 1881. Oil, 25 x 31½″. Collection Mr. and Mrs. L. M. Battson, Beverly Hills. (L.A.)

* 29 *Fisherman's Cottage on the Cliffs at Varengeville.* 1882. Oil, 24 x 32¼″. Museum of Fine Arts, Boston, Ill. p. 17

30 *The Harbor at Dieppe.* (c. 1882). Oil, 23 x 28½″. Private collection, New York

31 *The Road from Granval.* 1883. Oil, 25½ x 32″. Collection Mr. and Mrs. George Lawrence Simmonds, Highland Park, Ill. (N.Y.)

32 *Bordighera.* 1884. Oil, 25⅝ x 35¾″. Collection Mr. and Mrs. Josef Rosensaft, New York

* 33 *Cap Martin, near Menton.* 1884. Oil, 26¾ x 33″. Museum of Fine Arts, Boston. Ill. p. 18

ETRETAT

34 *The Cliff at Etretat (La Porte d'Amont).* (c. 1868). Oil, 32 x 39½″. Fogg Art Museum, Harvard University, anonymous gift

35 *Rough Sea, Etretat (La Porte d'Aval).* 1883. Oil, 31⅞ x 39⅜″. Musée des Beaux-Arts, Lyon

* 36 *The Cliff at Etretat (La Manneporte).* 1883. Oil, 25¾ x 32″. The Metropolitan Museum of Art, Bequest of William Church Osborn, 1951. Ill. p. 20. (N.Y.)

* 37 *The Manneporte, Etretat.* 1885. Oil, 26 x 32¼″. Collection Baron and Baroness Philippe de Rothschild, Paris. Ill. p. 21

BELLE-ILE-EN-MER

* 38 *Rocks at Belle-Ile (The Needles of Port Coton).* 1886. Oil, 24 x 29″. Collection Mr. and Mrs. Erik Meyer, Copenhagen. Ill. p. 9

39 *Rocks at Belle-Ile (Le Rocher du Lion).* 1886. Oil, 25 x 31½″ Collection Mrs. Oliver Parker, London

ANTIBES

40 *Antibes.* 1888. Oil, 25½ x 32″. Collection Mr. and Mrs. William Coxe Wright, St. Davids, Pa.

* 41 *Antibes.* 1888. Oil, 29⅛ x 36½″. The Toledo Museum of Art. Ill. p. 19

42 *Antibes.* 1888. Oil, 25¾ x 36⅜″. The Metropolitan Museum of Art, Bequest of Julia W. Emmons, 1956

* 43 *Torrent on the Petite Creuse.* 1889. Oil, 25¾ x 36¼″. Collection Miss Adelaide Milton de Groot, New York. Ill. p. 18

44 *Flowers.* (1890). Oil, 26 x 39⅞″ Collection Edward Gilbert, New York *Flowers (Semis de fleurs,* cat. no. 44), dated 1890 in the catalogue list, may be as early as 1885.

HAYSTACKS

45 *Haystacks at Giverny.* 1884. Oil, 25¾ x 36¼″. Collection Mr. and Mrs. Josef Rosensaft, New York. Ill. p. 22

46 *Haystacks in Snow.* 1891. Oil, 25¾ x 36¼″. The Metropolitan Museum of Art, Bequest of Mrs. H. O. Havemeyer, 1929. The H. O. Havemeyer Collection

* 47 *Haystacks, end of summer.* 1891. Oil, 23⅝ x 39⅜″. Collection Durand-Ruel, Paris. Ill. p. 24

* 48 *Two Haystacks.* 1891. Oil, 25½ x 39¼″. The Art Institute of Chicago, Mr. and Mrs. Lewis L. Coburn Collection. Ill. p. 25

* 49 *Two Haystacks.* 1891. Oil, 25⅝ x 39½″. J. H. Whittemore Company, Naugatuck, Conn. Ill. p. 25

50 *Haystack at Sunset near Giverny.* 1891. Oil, 29½ x 37″. Museum of Fine Arts, Boston, Juliana Cheney Edwards Collection

51 *Haystack.* 1891. Oil, 26 x 36¼″. Anonymous loan through Museum of Fine Arts, Boston. (N.Y.)

52 *Haystacks, setting sun.* 1891. Oil, 25½ x 39¼″. The Art Institute of Chicago, Potter Palmer Collection

53 *Haystack, foggy morning.* 1891. Oil, 23⅝ x 39½″. J. H. Whittemore Company, Naugatuck, Conn.

POPLARS ON THE RIVER EPTE

54 *Poplars on the Epte.* 1890. Oil, 36⅜ x 29″. The Trustees of The Tate Gallery, London

* 55 *Poplars.* 1891. Oil, 39½ x 25¾″. Philadelphia Museum of Art, Bequest of Anne Thomson as a memorial to her father, Frank Thomson, and her mother, Mary Elizabeth Clarke Thomson. Ill. p. 28

56 *Poplars.* 1891. Oil, 36¼ x 29″. Philadelphia Museum of Art, given by Chester Dale

* 57 *The Four Poplars.* 1891. Oil, 32¼ x 32⅛″. The Metropolitan Museum of Art, Bequest of Mrs. H. O. Havemeyer, 1929. The H. O. Havemeyer Collection. Ill. p. 29

* 58 *Poplars, wind effect.* 1891. Oil, 39⅜ x 28¾″. Collection Durand-Ruel, Paris. Ill. p. 27

59 *Poplars on the River Epte.* (c. 1891). Oil, 32¼ x 32″. National Gallery of Scotland, Edinburgh

60 *Poplars on the River Epte.* (c. 1891). Oil, 39¼ x 23½″. Collection H. E. Coombe, Cincinnati

VERNON

61 *The Church at Vernon.* 1883. Oil, 25½ x 32″. Collection Mr. and Mrs. John Barry Ryan, New York. Ill. p. 17. (N.Y.)

62 *The Church at Vernon.* 1894. Oil, 26 x 36½″. The Brooklyn Museum, New York

63 *Spring.* (1903). Oil, 35 x 36½″. Collection Mr. and Mrs. Josef Rosensaft, New York

ROUEN CATHEDRAL

64 *Rouen Cathedral in Mist.* 1894. Oil, 41¾ x 28¾″ Collection Mr. and Mrs. Roger L. Stevens, New York

65 *Rouen Cathedral.* 1894. Oil, 39¼ x 25⅞″. The Metropolitan Museum of Art, The Theodore M. Davis Collection. Bequest of Theodore M. Davis, 1915. (N.Y.)

66 *Rouen Cathedral, early morning.* 1894. Oil, 41¾ x 29⅛″. Museum of Fine Arts, Boston

67 *Rouen Cathedral: The Fasade at Sunset.* 1894. Oil, 39½ x 25¾″. Museum of Fine Arts, Boston

68 *Rouen Cathedral: The Fasade in Sunlight.* 1894. Oil, 39⅜ x 25⅝″. Collection Durand-Ruel, Paris. Ill. p. 33

69 *Rouen Cathedral.* 1894. Oil, 41½ x 29″. Collection M. and Mme Robert Kahn-Sriber, Paris

MOUNT KOLSAAS, NORWAY

70 *Mount Kolsaas, Norway, fog.* (1895). Oil, 25¾ x 39⅜″. Collection Michel Monet, Sorel-Moussel, France

71 *Mount Kolsaas, Norway.* (1895). Oil, 24¾ x 36½″. Collection Michel Monet, Sorel-Moussel, France

72 *Mount Kolsaas, Norway.* (1895). Oil, 25¾ x 36¼″. Collection Michel Monet, Sorel-Moussel, France

MORNINGS ON THE SEINE

73 *Morning on the Seine near Giverny.* 1897. Oil, 32⅛ x 36⅝″. The Metropolitan Museum of Art, Bequest of Julia W. Emmons, 1956

74 *Morning on the Seine.* 1897. Oil, 32 x 36″. Collection Mr. and Mrs. Reinaldo Herrera, Caracas

* 75 *Morning on the Seine.* 1897. Oil, 35⅛ x 36½″. Collection Mr. and Mrs. Dudley S. Blossom, Jr., Cleveland. Ill. p. 38. (N.Y.)

LONDON

* 76 *Charing Cross Bridge.* (1899-1904). Oil, 25½ x 36½″. The New Gallery, Inc., New York. Ill. p. 37.

* 77 *Charing Cross Bridge.* (1899-1904). Oil, 25¾ x 39½″. The Baltimore Museum of Art, gift of Mrs. Abram Eisenberg. Ill. p. 36

78 *Charing Cross Bridge.* 1903. Oil, 29 x 39½″. City Art Museum of St. Louis

79 *Charing Cross Bridge.* 1904. Oil, 26 x 39¾″. Collection Mr. and Mrs. Werner E. Josten, New York. (N.Y.)

80 *Leicester Square by Night.* (1899-1904). Oil, 31⅝ x 25½″. Collection Michel Monet, Sorel-Moussel, France

81 *Leicester Square by Night.* (1899-1904). Oil, 31¾ x 25⅜″. Collection Michel Monet, Sorel-Moussel, France

82 *Waterloo Bridge.* 1902. Oil, 26 x 37″. Collection Mr. and Mrs. Mahlon B. Wallace, Jr., St. Louis

83 *Waterloo Bridge.* 1903. Oil, 25 x 39″. The Rochester Memorial Art Gallery, Rochester, New York

* 84 *Waterloo Bridge, sun in fog.* 1903. Oil, 28¾ x 39″. The National Gallery of Canada, Ottawa. Ill. p. 35

85 *Waterloo Bridge.* 1903. Oil, 25¾ x 36⅜″. Worcester Art Museum, Worcester, Massachusetts

86 *The Houses of Parliament.* 1903. Oil, 32 x 36⅜″. Atlanta Art Association, The Great Painting Fund, Atlanta, Georgia. (N.Y.)

87 *The Houses of Parliament, seagulls.* 1903. 32 x 36″. Private collection, New York.

* 88 *The Houses of Parliament.* 1904. Oil, 32 x 36½″. Kaiser-Wilhelm-Museum, Krefeld, Federal Republic of Germany. Ill. p. 35

89 *The Houses of Parliament, sun in fog.* 1904. Oil, 32⅛ x 36¼″. Collection Durand-Ruel, Paris

VENICE

Although the pictures of this group are dated 1908, Monet worked on them later at Giverny, and some were not finished until 1912.

90 *Palazzo da Mula, Venice.* 1908. Oil, 26 x 37″. Collection Mr. and Mrs. Mahlon B. Wallace, Jr., St. Louis

91 *The Doge's Palace, Venice.* 1908. Oil, 32 x 39½″. The Brooklyn Museum, New York, gift of A. Augustus Healy

92 *The Doge's Palace, Venice, as seen from San Giorgio Maggiore.* 1908. Oil, 25½ x 36″. Collection Paulette Goddard Remarque, New York. (N.Y.)

93 *The Doge's Palace, Venice, as seen from San Giorgio Maggiore.* 1908. Oil, 25⅝ x 39⅜″. Collection Mr. and Mrs. J. K.

Thannhauser, New York. Lent through the Thann-
hauser Foundation, Inc. (L.A.)

* 94 *The Contarini Palace, Venice.* 1908. Oil, 28⅞ x 36¼". Col-
lection Dr. and Mrs. Ernest Kahn, Cambridge, Massa-
chusetts. Ill. p. 42

 95 *San Giorgio Maggiore, Venice, twilight.* 1908. Oil, 25¾ x
36⅜". The National Gallery of Wales, Cardiff, Gwen-
doline E. Davies Collection

 96 *The Grand Canal, Venice.* 1908. Oil, 29 x 36½". Museum
of Fine Arts, Boston

 97 *Palazzo Dario, Venice.* 1908. Oil, 25½ x 31". The Art
Institute of Chicago, Mr. and Mrs. Lewis L. Coburn
Collection

 98 *Palazzo Dario, Venice.* (1908). Oil, 22 x 26". Collection
Mr. and Mrs. Henry J. Heinz, 2nd, Pittsburgh. (N.Y.).
In all probability this canvas was completed in Venice.

THE JAPANESE FOOTBRIDGE

* 99 *The Japanese Footbridge and the Water Lily Pool.* 1899. Oil,
35¼ x 36½". Collection Mrs. Albert D. Lasker, New
York. Ill. p. 39

 100 *The Japanese Footbridge and the Water Lily Pool, harmony in
rose.* (1900). Oil, 35 x 39⅜". Musée du Louvre, Paris

*101 *The Japanese Footbridge.* 1919. Oil, 25½ x 42⅛". Col-
lection Sam Salz, New York. Ill. p. 48. (N.Y.)

 102 *The Japanese Footbridge. (Pond and Covered Bridge).* (1920-
22). Oil, 35¼ x 45⅛". The Museum of Modern Art,
New York, Grace Rainey Rogers Fund

 103 *The Japanese Footbridge.* (1920-22). Oil, 35 x 36¾".
Collection Mr. and Mrs. Walter Bareiss, Greenwich,
Connecticut

 104 *The Japanese Footbridge.* (1920-22). Oil, 34⅝ x 41⅜".
Collection Mme Katia Granoff, Paris

THE WATER GARDEN

 105 *The Water Lily Pool.* 1904. Oil, 35⅛ x 36⅜". Denver Art
Museum, Helen Dill Collection

*106 *Water Lilies.* 1905. Oil, 35¼ x 39¼". Museum of Fine
Arts, Boston. Ill. p. 41

 107 *The Water Lily Pool.* 1906. Oil, 35 x 39⅜". Collection
Durand-Ruel, Paris

 108 *The Flowering Arches.* 1913. Oil, 32 x 36½". Collection Mr.
and Mrs. Charles Goldman, New York

 109 *Water Lilies.* 1917. Oil, 39⅜ x 78¾". Musée des Beaux-
Arts, Nantes

 110 *The Water Lily Pool.* (1917). Oil, 55¼ x 59¼". Collection
Mr. and Mrs. Edward G. Robinson, Beverly Hills. (L.A.)

 111 *Water Lilies.* (c. 1918). Oil, 52½ x 79". Collection Larry
Aldrich, New York

 112 *Water Lilies.* (c. 1918). Oil, 51 x 79". Collection Mr. and
Mrs. Joseph Pulitzer, Jr., St. Louis. (N.Y.)

*113 *Wisteria.* (1918-20). Oil, 59 x 79". Allen Art Museum,
Oberlin College, Oberlin, Ohio (formerly collection Paul
Rosenberg & Co., New York) Ill. p. 49

*114 *Agapanthus.* (1918-26). Oil, 79⅛ x 71". Collection Mr.
and Mrs. Joseph Slifka, New York. Ill. p. 51

 115 *Yellow Iris.* (1918-26). Oil, 63 x 39". Collection Dr.
Ralph André Kling, New York **Cat. no. 115, for 63" read 78½"**

*116 *Weeping Willows.* 1919. Oil, 39½ x 47½". Collection
Mr. and Mrs. David Rockefeller, New York. Ill. p. 47

 117 *Weeping Willows.* (c. 1919). Oil, 43¼ x 39⅜". Collection
Mme Katia Granoff, Paris

*118 *Water Lilies.* (c. 1920). Oil on canvas in triptych form,
each section 6' 6" x 14'. The Museum of Modern Art,
New York, Mrs. Simon Guggenheim Fund. Ill. pp. 44-45

 119 *Water Lilies.* (c. 1920). Oil, 6' 6" x 12' 2". Collection Mme
Katia Granoff, Paris **Cat. no. 119, for 12' 2" read 14'**

SELECTED BIBLIOGRAPHY

This list includes only the most useful books and a few valuable articles. More extensive bibliographies appear in nos. 7, 13, 16, and 17. Additional references appear above in the "Notes to the Text," and the most important catalogue essays are cited in the "Biographical Outline and List of Major Exhibitions." An illustrated catalogue of Monet's *oeuvre* is now being prepared by Mr. Daniel Wildenstein.

1 ALEXANDRE, ARSENE. Claude Monet. Paris, 1921.

2 BACHELARD, GASTON. Les Nymphéas ou les surprises d'une aube d'été. *Verve* 7 nos. 27-28: 59-67. 1952.

3 BAZIN, GERMAIN. French Impressionists in the Louvre. New York, Abrams, 1958.

4 CLEMENCEAU, GEORGES. Claude Monet, Les Nymphéas. Paris, Plon, 1928.
 Also in English translation by George Boas, Garden City, N. Y., 1930.

5 FELS, MARTHE DE. La vie de Claude Monet. Paris, Gallimard, 1929.

6 FOSCA, FRANÇOIS. Claude Monet. Paris, L'artisan du livre, 1927.

7 GEFFROY, GUSTAVE. Claude Monet, sa vie, son temps, son oeuvre. Paris, Crès, 1922.
 Also 2-volume edition, 1924. Despite omissions and errors, this rambling book by Monet's famous friend is the richest single account to date of Monet's art and life.

8 GILLET, LOUIS. Trois variations sur Claude Monet. Paris, Plon, 1927.

9 GREENBERG, CLEMENT. The later Monet. *Art News Annual* 26: 132-148, 194-196, 1957.
 Same issue contains: Monet, C. Monet as a young man, p. 127-128, 196-199. (See note 3, p. 53).

10 GWYNN, STEPHEN. Claude Monet and his Garden. London, Country Life, 1934.
 Also New York, Macmillan, 1935. Includes excellent photographs of Monet's water garden.

11 HAMILTON, GEORGE H. Claude Monet's Pictures of Rouen Cathedral. London, Oxford University Press, 1959.
 Charlton Lecture on Art, King's College, University of Durham, Newcastle upon Tyne.

12 LEYMARIE, JEAN. Impressionism. Lausanne, Skira, 1955. (Taste of our Time, no. 11 and 12.)

13 MALINGUE, MAURICE. Claude Monet. Monaco, Les Documents d'Art, 1943.

14 MASSON, ANDRÉ. Monet le fondateur. *Verve* 7 nos. 27-28: 68-69. 1952.

15 REGAMEY, RAYMOND. La formation de Claude Monet. *Gazette des beaux-arts* 69: 65-84, Feb. 1927.

16 REWALD, JOHN. The History of Impressionism. 2nd ed. New York, The Museum of Modern Art, [1955, c. 1946].
 A revised edition is now in preparation.

17 ROUART, DENIS. Claude Monet. Geneva, Skira, 1958. (Taste of our Time, no. 25)
 Introduction and conclusion by Léon Degand. Translated by James Emmons.

18 SABBRIN, C. Science and Philosophy in Art. Philadelphia, 1886.

19 SEITZ, WILLIAM C. Claude Monet. New York, Abrams, 1960. (Library of Great Painters.)

20 USENER, KARL H. Claude Monets Seerosen-Wandbilder in der Orangerie. *Wallraf-Richartz-Jahrbuch* 14: 216-225. 1952.

21 VENTURI, LIONELLO. Les archives de l'impressionnisme. 2 v Paris, New York, Durand-Ruel, 1939.
 An essential collection of impressionist history, contemporary criticism, and documents. Includes 411 letters from Monet to the Durand-Ruel family as well as 6 to Octave Maus.

Printed by Brüder Hartmann, Berlin, Germany (pages 5-52) and Connecticut Printers, Hartford, Connecticut (pages 1-4; 53-64) in March 1960 for the Trustees of the Museum of Modern Art.